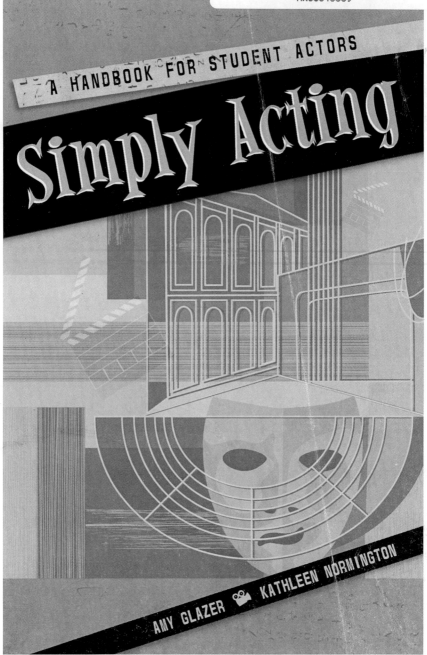

A HANDBOOK FOR STUDENT ACTORS

Simply Acting

AMY GLAZER KATHLEEN NORMINGTON

Kendall Hunt
publishing company

Cover art © 2010 Shutterstock, Inc.

Kendall Hunt
publishing company

www.kendallhunt.com
Send all inquiries to:
4050 Westmark Drive
Dubuque, IA 52004-1840

Printed in the United States of America
10 9 8 7 6 5 4 3

Contents

Preface

During our years teaching and coordinating our popular beginning acting course at San Jose State University, one of our delights has been to unify and coordinate the many sections of the course; this has required refining the language of acting and developing an approach to performance training that weaves together the varied aspirations of our students and the vision of our program. Over the years, Amy developed a popular course focusing on film acting (Chapter 7). Kathleen explored the importance of a distinctly physical approach to acting and vocal techniques (Chapter 3). However, our main task of refining the beginning acting curriculum was ever-present. Together, we tested out new ideas and approaches, new texts, a range of plays, and assessed what worked and what didn't.

What didn't work were the introductory acting textbooks! We adopted a new text every year, but never found anything that demystified for beginners the art and craft of authentic acting and professional theatre or conveyed its values and vocabulary. We wanted a text that spoke to both stage and film actors, that clarified terminology, and that, at its core, laid a foundation for the many performance grammars that informed our teaching.

For six years we would declare at the end of each spring semester, "Let's write our own book!" and then, overwhelmed by our own professional projects, we would watch another summer quickly come and go. Then we finally did it. Although a work-in-progress, our first edition, inspired by years of research in training students from diverse backgrounds and social traditions, in majors ranging from Nursing to Psychology to Animation, is now out in the world. We have poured our passion for the acting process into this text.

This handbook is for you, the first-time actor interested in speaking the language of acting and learning the essential values inherent in responsible and credible actor training. It is a shorthand guide that will also help those who teach beginning performance to build and structure an acting class ensemble and training lab.

We want to acknowledge the many graduate students and professors who have taught this class over the years and who have helped us to assess and explore the boundaries of a positive and rigorous beginning acting class. Most especially we wish to thank Beverly Swanson, Laura Long, Billie Shepard, David Scott, Will Brown, and actor Rod Gnapp; we thank our editor, Elizabeth Sharf, who clarified our ideas with grace and humor, and James Connolly, whose life-saving publishing expertise reached us in the nick of time. And we are wholeheartedly grateful to our "Chair Extraordinaire," Dr. Anne Fountain, who nudged us to finish *this* summer.

We also cannot fail to acknowledge Kathleen's first acting professor, Jim Kirkwood, who passed away just this year. Jim's passion for the art of acting, his compassion for his students, and his exemplary teaching style continue to inform and guide us today.

Finally, we want to recognize Amy's mother and a master teacher in her own right, Zelda Glazer, who taught us that skillful teaching invariably yields great rewards, that a well-crafted curriculum has power and substance, and that teacher preparation is key.

introduction

The Courage to Act

> The stage is a place where the stakes are raised intentionally. A body is put in crisis intentionally. For the actor, it should cost something to walk across the stage. In art, every task should cost something to accomplish, and the stakes can always be lifted higher. Stepping upon the stage should feel like jumping off of a high diving board at the Olympic pool.
>
> Anne Bogart

Every human being has the impulse to act—events and situations trigger reactions in all of us. What distinguishes the actor is the uncanny ability to respond to the impulse to act *in front of an audience* and *with courage*. Although actors can make this appear easy, it takes training and hours of practice to achieve competence as an actor. This handbook provides the beginning actor with the lexicon, tools, and standard practices essential to acting.

Acting is not pretending. It is *doing* something in relation to the situation provided by the script. The actor fulfills the dramatic function of the character and helps tell the story of the play or film. This is the

actor's primary function. To act is an active verb—this will be helpful to remember as you begin your acting journey. The actor acts as a liaison between the audience members who view the performance and the playwright, director, and designers who are interpreting the script. An inventive actor offers the audience a compelling, authentic interpretation of the character while honoring the playwright's original story. Whether playing the protagonist (hero) or the antagonist (villain), the inventive actor will not pass judgment on the character he or she plays; rather, the actor will uncover with tolerance and compassion their humanity.

When writer C.S. Lewis writes of our spiritual "good" and "bad" impulses, he could also be speaking to the beginning actor. He asserts that, in the same way that every single note of a piano is right at certain times and wrong at other times, there are no right or wrong impulses in spiritual life.[1] So, too, do you as an actor have a whole set of "notes" that you will learn to play at the appropriate moments in your creative life; a big part of your job as an actor is to be able to summon the courage to access these "notes" without censoring yourself.

It is an act of great courage to pursue acting. In *A Sense of Direction: Some Observations on the Art of Directing*, stage director William Ball has written, "All acting is praiseworthy if for no other reason than that the actor has the courage to walk from the wings to the center of the stage." He continues, "What reward could be so great for an actor to face such great fear? The reward may be that in overcoming his fear the actor feels a true sense of freedom and liberation while acting—the ultimate human experience, the joy of prolonged unity."[2]

Overcoming stage fright is something that even the most experienced actor has to face at various times. It is a well-known fact that the fear of public speaking is far greater for most people than the fear of death or serious illness. By completely engaging your mind and body in completing the tasks of your character, you can conquer stage fright. In other words, by committing fully to the acting process, your focus will be on pursuing your character's objective, not on yourself; this will diminish your stage fright, which is rooted in excessive self-consciousness.

Your teacher will be absolutely supportive of your efforts to learn to act by removing obstacles to your success and maintaining an emotionally safe class environment while encouraging you to take risks and be creative. It is important that a class culture be established that cultivates the group or the acting ensemble over the "star" performer.

Your teacher knows that helping you overcome your fear is one of the first steps to liberating the actor within you, and he or she will introduce a variety of group games to create a sense of bonding between all the actors in the class. This in turn will help you feel less self-conscious and increase your trust that you are in a supportive acting ensemble full of beginners willing to take risks along with you.

Finally, in learning to control fears, you must develop a strong work ethic. This, perhaps more than anything else, separates the professional actor from the amateur. By establishing and maintaining a discipline of exhaustive preparation, you will free yourself from the self-consciousness that contributes to stage fright.

Every class will have students with all levels of experience and—let's face it—differing levels of both talent and that illusive quality of

"presence." However, everyone is capable of learning the skills in this text and applying them when performing. Acting can be learned!

The obligations of the actor on stage or screen are many. An actor must hold many things in his or her head at once and, at the same time, fully listen to his or her fellow actor, ready to respond. A popular term used today is *multitasking* and, for the actor, this is an essential skill to cultivate. There are lines to learn, a psychological score to internalize, stage movements to remember, props and costumes to handle, other actors to respond to, and of course, the audience— different every night and a key factor in every performance.

In performance, anything can go wrong at any time, and the actor must never break character. Incorporate the accidents. A stage mishap or accident, and the obstacles it creates, can elevate both the comedy and the drama. Stay ready to embrace the unknown and the unexpected.

Finally, respect is indispensable in creating an environment that makes you feel courageous and supported. Respect for your classmates and your instructor is essential, but so is respect for yourself both in your successes on stage but more importantly in your failures. There will be times when you will fall short of your own expectations, and the acting lab is just the place to do so. It is not a place for judgment. An actor learns more from failure than success, and the more you get up on stage and swing big, and sometimes fail, the sharper and brighter your work will become. In the words of playwright Samuel Beckett, "Ever tried. Ever failed. No matter, try again, fail again. Fail better."[3]

With that advice in mind, you will take greater risks in your acting lab, which will result in exciting performances and great personal satisfaction.

Finally, as you undertake the challenge of learning to act, be sure to peruse the contemporary plays and modern classics in Appendix A and the books on acting in Appendix B; these will arm you not only with material to practice, but also with sound advice to inspire you along the way. Also, consult the Glossary at the back of the book often; it contains terms and concepts for the worlds of theatre and film acting that you will find useful in carrying out the exercises in this handbook.

Endnotes

1. C. S. Lewis, *Mere Christianity* (New York: HarperCollins, 2001), 20.

2. William Ball, *A Sense of Direction* (Hollywood: QSM, 1984), 176.

3. Samuel Beckett, *Worstward Ho* (New York: Grove Press, 1983), 42.

* acting ≠ pretending
* your job to fulfill play's function and tell story

* everyone gets stage fright

Chapter 1

The Actor's Heritage:
The Past Informs the Present

Freshness, beauty, a pleasant broad face, red lips, beautiful teeth, a neck round as a bracelet, beautifully formed hands, graceful build, powerful hips, charm, grace, dignity, nobility, pride, not to speak of the quality of talent.

Demands of the Actor in Ancient India

An actor is a sculptor who carves in snow.

Edwin Booth

→ lasting v. short time

Acting is specific yet ephemeral. When examining the traditions of the past, you will rediscover skills essential for actors today. This chapter provides a brief historical overview that will demonstrate how the craft of acting has evolved from its traditional roots into contemporary performance styles and forms. Historically, the actor's status has been buffeted by political, socioeconomic, and religious factors. These conditions have influenced the nature of the art form.

Acting Conventions and Style

Every historical era has distinct acting *conventions*. Conventions are the grammar of performance; they are the standard procedures or practices unique to acting in any given time period. When you practice movement and gesture exercises you are reflecting the skills developed by the actors of ancient Greece or India; when you work with masks, you are facing the same challenges that the early Commedia dell'arte actor of the Italian Renaissance or the Japanese Noh actor faced centuries ago; and in improvisational exercises you are applying skills cultivated by Commedia dell'arte actors in sixteenth-century Italy.

The main objective for the actor in any given time period has basically remained the same: to cultivate a strong and flexible body, voice, and mind in order to create a performance that holds the audience's attention—a performance that entertains. This traditional aspiration of the actor underlies the principles put forward in this handbook.

The social status of actors, however, has changed over time. While actors today, in particular those working in film, are highly regarded and handsomely paid, it was not always so for a man or woman who chose acting as a profession. Still, for many actors today, the vocation

comes with huge sacrifices, minimum wages, and a gypsy's life. For that reason acting is a calling, and if you choose to pursue it professionally, be sure you find a day job! Remember, however, that you are also part of a rich and storied tradition.

Aristotle and *The Poetics*

The evolution of the actor in the West can be found in the writings of the classical Greek philosopher Aristotle (384–322 BCE) whose masterwork *The Poetics* analyzes the nature of drama as well as the role of the performer. Aristotle describes the dramatic character as an "agent for action" and that pronouncement alone gives us a clue to the style of acting in his day. Theatre in ancient Greece was a communal ritual in which the members of the community (later formalized as the *chorus*) chanted or sang songs in unison to honor Dionysus, the god of wine and theatre. The choral nature of this performance continued until a member of the chorus, a performer named Thespis (hence the term *thespian* to describe an actor), stepped out of the chorus to speak opposite the chorus on his own. This momentous first *dialogue* is revered as the genesis of all dramatic and film literature in the West today.

Aristotle wrote of this event two centuries later and credited Thespis with inventing a new style of drama: tragedy. A playwright as well as an actor, Thespis is regarded traditionally as the first winner of the drama competition called the City Dionysia. He is also credited with the addition of masks and costumes to performances. Actors are not surprisingly often playwrights. Shakespeare is best known as a playwright but was also an actor, and in theatre and film today we have the highly successful examples of Sam Shepard and Tracy Letts.

Actors by nature are creative beings and often embrace multiple aspects of artistic expression such as writing, painting, music, and directing.

One revealing anecdotal account of the nature of acting in ancient Greece concerns an actor named Polus who was performing in Athens in the play *Electra* by Sophocles around the fourth century BCE. One key moment in the play has Electra holding an urn containing the ashes of Orestes, her brother. Polus, playing the role of Electra, apparently took from the tomb the ashes and urn of his own son (who had recently died) and embraced them as if they were those of Orestes. Even then the intuition to use the dramatic technique of *substitution* as a way of bringing authentic feeling to a moment on stage was second nature to the actor. Many years later this became the basis for what is commonly known as *method* acting.

The Sanskrit Actor of India

The classic Greek theatre of the fifth century is often considered the source of Western theater. However, the Sanskrit dramatic tradition that flourished in India for over two thousand years has also contributed to modern acting practices. Sanskrit drama provides a counterpoint to Aristotle. Sanskrit performance requires that actors master an elaborate codified system of facial expressions and hand gestures. This system, called the *abhinaya,* is presented in the book *Natyasatra,* written by several authors around the second century CE.

The Sanskrit actor performs alone onstage, reacting to an action that is happening offstage. For example, the audience will observe the reaction of the actor but not see the action that is causing it. The actor

performs a pattern of emotional responses, which are *triggered by the action* (for example, the death of the offstage character). The actor in Sanskrit drama therefore masters and must perform a series of codified actions that reveal a connection to an offstage incident; the lesson here for the beginning actor is to understand how crucial it is in a scene or monologue to react not just act. The actor *fills* in events that the audience does not see. The goal is the same for both the Sanskrit actor and the contemporary actor, but the process for reaching these goals is quite different. The Sanskrit actor trained in a formalized acting system, while actors today can choose from a variety of training approaches.

The Japanese Noh Actor

The Japanese dance theatre known as Noh requires the actor to train from an early age in a formalized system of actor preparation that has changed little over time. Noh is a non-realistic form of theatre that evolved in the fourteenth century from a kind of religious entertainment and continues to be performed in Japan today. The term *Noh* comes from the Japanese *nō* which means "talent" or "skill." Precise, rigorous, and physical acting conventions are transmitted from generation to generation through oral transmission. Each performance maintains a connection to its predecessor. The scripts, or performance texts, contain meticulous prescriptions for dance, mime, and movement. Traditionally, the central actors are male and wear masks that require the actor to communicate every nuance of character, gender, and circumstance through a bodily grammar acquired through years of training.

For the past thirty years, the Noh aesthetic and its acting techniques have been adapted for contemporary theatre performances by master teacher Tadashi Suzuki. Suzuki translates the fundamentals of Noh for the contemporary actor in performances that rely on the acting ensemble and are living and vibrant.

Acting in the Elizabethan and Italian Renaissance

The Elizabethan actor relied on his voice because the text—the word—was the key element of the production. Playwright and actor William Shakespeare makes several references to the art and technique of acting in many of his plays but particularly in *Hamlet*. When offering advice to the troupe of players he hires to perform, Hamlet admonishes them to not make the mistake that poor actors make who over-embellish their text by overacting, but rather to:

> Speak the speech, I pray you, as I pronounced it to you, trippingly on the tongue. . . . Nor do not saw the air too much with your hand, thus, by use all gently, for in the very torrent, tempest, and (as I may say) whirlwind of your passion, you must acquire and beget a temperance that may give it smoothness. . . . Be not too tame neither, but let your own discretion be your tutor. Suit the action to the word, the word to the action, with this special observance, that you o'erstep not the modesty of nature. For anything so overdone is from the purpose of playing, whose end, both at the first and now, was and is, to hold, as 'twere, the mirror up to nature, to show virtue her own feature, scorn her own image, and the very age and body of the time his form and pressure. (Act III, Scene 2)

What Shakespeare is suggesting here is that the actor be truthful and honest in his portrayal of a character and make every action, every choice, authentic.

During the sixteenth and seventeenth centuries in Italy, Commedia dell'arte was a popular form of theatre and the actors had to master a vocal and physical style in addition to improvisational skills. There were no formal scripts for commedia performances; instead there were outlines of formulaic plots or situations. Most of the stock commedia characters were performed with masks that covered one side of the face, making movement more important. Today when you attend a ComedySportz performance or perform your own class improvisations, you are keeping alive a tradition that was first inspired five hundred years ago.

Modern Systems of Acting: Stanislavski

The subculture that grew up around acting in the United States was rooted in adversity and insecurity for the many actors who were not star performers. Creation of the Actor's Society of America, a quasi-union, in 1894 improved working conditions. It wasn't until 1913, however, when the Actors Equity Association, a bona fide union for stage actors, was founded that the rights of actors became fully protected; the union remains active today.

Early in the twentieth century the dominant style of acting was grand, exaggerated, and far from realistic. However, with the growing popularity of realistic literature and motion pictures the art of acting also underwent a transformation.

The acting revolution began in Russia with the teaching and writings of Constantin Stanislavski (1863–1938). Stanislavski developed his system from his own frustrations as an actor and also from his observations of the great actors of his day. The Stanislavski system helps the actor translate a story to the stage or screen in an effortless, simple, authentic, and truthful way. It is the basis for the approach in this workbook.

The Stanislavski system was adopted and interpreted by a number of great teachers and directors in America. These include Lee Strasberg, Stella Adler, Herbert Berghov, Michael Chekhov, Uta Hagen, and Sanford Meisner. Please see Appendix B for suggested reading about these important teachers of acting.

You will also find in Appendix B authors who have been inspired by the legacy of the Sanskrit, Noh, and Commedia dell'arte theatre traditions. Their varied approaches to storytelling embrace non-realistic performance techniques. These teacher-directors include Peter Brook, Anne Bogart, Vsevolod Meyerhold, Antoine Artaud, Jerzy Grotowski, Augusta Boal, and Tadashi Suzuki.

All of the practitioners and teachers mentioned have informed our approach to the art of acting. As you peruse these resources find those that excite and stimulate your imagination and that speak directly to you. This will help you to develop your own personal acting toolbox of techniques and approaches; then, if and when your intuition fails you and a moment begins to feel false and inactive, you can open your toolbox and navigate the challenges inherent in a new script or a new character.

Welcome to this rich and diverse tradition. You are about to join a long line of distinguished performers.

no matter how old or new, the techniques will work
go with what feels right

Chapter 2

Scoring Your Script:
The Language of Acting

> ✳ Acting is half shame, half glory. Shame at exhibiting yourself, glory when you can forget yourself.
>
> John Gielgud

One of the greatest challenges in acting is losing your self-consciousness—the part of you that stands outside yourself and makes you feel awkward and embarrassed. As you will learn in the course of this chapter, by developing a psychological score for your character you can redirect your focus from yourself to your acting partner. This will transform your experience of performing on stage or on camera from one of anxious discomfort to one that is active and engaged, filled with deep satisfaction and pleasure.

There is a specific language for communicating about performance that will help you articulate your thoughts, both orally and in writing,

about your own and other actors' performances, and will also help you understand how to adjust your own performance when critiqued. This language allows actors and directors to discuss the craft of acting in a succinct and productive way and comprises the key elements of your score. It also allows you to make adjustments to your performance without confusion or anxiety. While there are countless approaches to the modern acting process, we have chosen language that is universal to the approach based on the teachings of Constantin Stanislavski (1863–1938; see Appendix B), perhaps the most famous name in the history of modern drama.

The language covered in this chapter amounts to a basic lexicon for every beginning actor. Because this is an acting book, we discuss this vocabulary in the context of performing a scene. You will learn to "score your script" by interpreting the individual psychological moments in a scene. The ancient Greek word for an actor is, after all, *hypokrite,* which literally means "one who interprets." An actor is one who interprets a dramatic character and, in so doing, internalizes and inhabits that character. The first step in beginning to act is beginning to interpret: *if* I were in this situation, *if* this were my life, or wife, or job . . . what would I do? What would I want? How would I behave? Stanislavski calls this the *magic If.* The more you glean clues from the text that help you interpret it and thereby make particular choices, and then internalize those choices as you inhabit your character, the more seamless and authentic your transformation into that character will be.

Elements of a Score

The process of discovering, understanding, and finally, interpreting the character truthfully, believably, and with specificity starts with analyz-

ing the play and understanding the *given circumstances* of a play. Given circumstances are the conditions of the play that include specific information about the physical environment, the time, the place, the weather, the situation, and the character's emotional and physical states. They include information regarding relationships and psychological dynamics between characters. Tony Barr in *Acting for the Camera* suggests that:

> It is important to remember that the playwright has laid out certain facts and conditions that you must understand and utilize as you prepare to play [act] moment-to-moment, since they determine where you are at any given moment emotionally, intellectually, sensorially, and physically. Those facts and conditions cannot be ignored. In Hamlet, for example, can we ignore the fact that Hamlet's father has recently died, and Hamlet suspects that he was murdered? Can we ignore the fact that a ghostly figure has appeared on the parapet in the first scene? Can we ignore the fact that it is cold on the parapet? That Hamlet loves his mother? That Hamlet hates his stepfather? How you, playing Hamlet, will respond to any given stimulus is determined in a very important way by those facts and conditions, i.e., the given circumstances of the play. (Barr, 69)

Antecedent action (or *antecedent beat,* described later) has a great deal of influence over the given circumstances—the current facts and conditions surrounding a scene. The antecedent action is what happens just before the play or scene begins; this informs and influences the expectations and objectives of the characters and therefore affects the direction of the scene. That is why not reading the entire play before performing a scene is foolhardy—and can even be treacherous!

(handwritten margin note: what happens before the play or scene)

Director Jon Jory in *TIPS: Ideas for Actors* advises the actor to write out a list of the given circumstances and then ask "Why?" He goes on to state the importance of the given circumstances for the actor: "Acting serves the text, and the text sets boundaries for the actor." This is your starting point; read the play and understand the facts and conditions as well as the *events* (discussed later) and *plot points* (who does what, with what, to whom, and why) of the play, because only then can you begin the process of figuring out who your character is and what your character wants.

based on motives / intentions / objective

Through a careful reading of the play, an actor discovers the *through line* or the *spine* of his or her character's situation or journey. A character's through line is based on a series of motives, or *objectives*. An objective is an immediate urgent goal, intention, or need of a character in a scene. What does the character want or need above all else at this particular moment? All of these objectives are informed by the overriding need or desire, which is called the *super objective*— the overall motivating desire that determines a character's behavior and actions or the character's *arc* (journey or transformation) throughout the play.

In *Hamlet*, our protagonist has a super objective to avenge the mysterious death of his father. Throughout his journey in the play, he has specific objectives: to find the perpetrator of the crime, to expose his uncle's culpability, to reveal the truth to his mother, etc. These objectives, like dominoes, comprise the through line/spine and incite the events that create the action as one domino topples over the next, creating a chain of events.

Once the actor has decided on the super objective and on a scene objective, the actor must create a series of *actions.* Like a musical score, these actions color each individual moment (*beat*) of a scene.

They also add dynamics and nuance. Actions are not passive states but incorporate specific choices and behaviors that help the character get what he or she wants (the objective) from the other actor or actors (sometimes called receivers or partners) in the scene.

These actions ultimately determine who your character is. Your character is revealed through behavior, and behavior is revealed by the way your character goes about getting what he or she wants. Several different actions comprise a tactic. The action is to a tactic what a part is to a whole.

If my objective, for example, is to gain power over the other character in the scene, and my tactic is to seduce this character in order to gain power, then my actions might be to make that character feel sexy, desired, or titillated. Objectives should be worded in terms of the receiver and refined until they carry the greatest weight, the highest stakes. For example, Hamlet's objective when giving direction to the "players" in the play within the play might be "I need to expose my father's killer in order to save my own life." In order to attain this objective, Hamlet might choose the tactic of exposing his uncle. His resulting actions might therefore be to make his uncle Claudius feel unsuspecting, blackmailed, bullied, challenged, and weak. These are playable actions because Hamlet is doing something to Claudius. Actions are keyed to tactics.

In short, actions can be discovered by completing the following statement: **I want to make him/her feel**_____.
Filling in the blank leads you to your actions.

Stakes are the importance we place on an objective. Often you will hear your teacher ask students to "raise the stakes," to intensify an objective, which is reflected in the way the objective is worded. In *The Glass Menagerie,* Laura's mother Amanda's objective is to get her

daughter married off. Here are two options for the actor playing Amanda: **Objective 1:** I want Laura to be married and taken care of, or **Objective 2:** I need Laura to find a husband who can take care of both of us so we are not destitute. With the wording of **Objective 2,** the actor playing Amanda has raised her stakes and, therefore, every obstacle is life threatening in Amanda's mind. Raising the stakes creates a more dynamic and dramatic performance in both comedy and drama.

An *obstacle* is a person, object, or emotional or physical state of being that gets in the way of your achieving the objective. The important thing is that when a character comes up against an obstacle it is inherently dramatic and therefore interesting. Your job as an actor is to look for obstacles in order to create dramatic opportunities in the scene.

A *beat* is a rhythmic unit equivalent to the count of one. Several beats, therefore, comprise the rhythm of a scene. A beat also defines the moment-to-moment *reversals* that occur between characters in a scene. These reversals/beats trigger a change in psychological or emotional direction in a scene. Beats are often determined and defined by what is unspoken—that is, what is happening between characters behind the actual spoken words (the *subtext*). Beats can be notated from your character's point of view by asking: is a particular moment in the scene good or bad for your character? Are you getting what you want in that moment (your objective)? When a moment turns, when a new tactic is employed, the beat shifts or changes and marks a new beat in your scene.

We also call these shifts or beat changes the *yeas* (good for me) and the *boos* (bad for me) of a scene. They can shift from moment to

moment, from line to line, and from action to action. Beats strung end to end with different actions/tactics and different obstacles create your character's psychological score from one moment to the next. A beat, according to Robert Lewis in *METHOD—Or Madness?*, is "the distance from the beginning to the end of an intention."

With greater understanding of your character will come a heightened sensitivity to subtext, the meaning and thought underlying the dialogue, or the actual words spoken. These unspoken thoughts— what a character chooses not to say, the stream-of-consciousness thoughts that flow underneath and between dialogue—are what make a performance unique and totally yours. These silent thoughts also define behavior and therefore reveal character. Subtext, as part of your score, can be used as a framing device before or after a line. It is also a way to set (establish) a particular reading of a line for a given performance. For example, if the line your character speaks is, "no thank you, nothing to drink for me," and you preface the line with the subtext or parenthetical thought, "he's trying to get me drunk," the line will be colored by that thought. A very different reading will result if you preface the same line with the parenthetical subtext, "wow, he's so cute and thoughtful." The interior thought colors and defines the meaning of the text and, therefore, is a powerful tool for shaping the meaning of a line and the tone of the delivery.

Once you have identified your objective, obstacles, actions, tactics, and parenthetical/subtextual frames, and found as many beat reversals (yeas and boos) in your scene as possible, a shape will emerge—your own personal score.

Shaping Your Scene

If the scene ends with a boo, try to start with a yea. At the beginning
of the opening scene of *A Streetcar Named Desire*, Stella is so excited
to see her sister, Blanche, but by the time the scene ends, she has
locked herself in the bathroom crying. Stella, when that scene is
played well, comes into the scene expecting and anticipating a won-
derful and happy reunion with her sister, a yea. That gives the scene
and the actress playing Stella a starting place far from where the scene
ends emotionally, with a boo. And therefore the scene takes on a sur-
prising and satisfying arc for both the audience and the actress.

In Chekhov's *The Cherry Orchard*, when Lopakhin is finally going
to propose to Varya, Varya is thrilled (yea). He starts dancing around
the question, and she acts distracted, busily packing her bags to leave
(boo). Lopakhin again attempts to muster up the courage and begins
the proposal; eager, Varya hangs on his every word, she wants this
(yea). Then someone calls to him and interrupts (boo). Lopakhin loses
his courage; he says he is coming and leaves. (That moment is the
event or the *It* in the scene). Varya is left alone; she cries (boo).

These mini-reversals are inherent in good dramatic writing, but
you must learn to look for them. By playing the reversals in the
moment-to-moment units of a scene, ever adhering to your character's
objective, you will take your audience through a surprising, com-
pelling, and dramatic journey.

This method of script analysis will also keep you from falling prey
to the common acting pitfalls of playing the end of a scene at the
beginning, giving equal weight to every moment in a scene, and defus-
ing or losing the tension or dramatic action inherent in the text.

Arc refers to the overall shape of an individual scene or an entire play. The best way to create a strong arc is to look at how the scene ends and take a position at the beginning of the scene as far away from that ending as the text can support. In every well-arced scene there is an event—the It. The event of the scene is the moment in the script where change occurs. To find this event, ask yourself, "What conditions exist at this moment that were absent when the scene began?" (This condition can be a change in a relationship, in a circumstance, in a mind-set, and so on.)

In analyzing your scene, decide at what point the event actually takes place. That exact moment is what we refer to as the actor's It. Often you will find that the It will occur towards the end of the scene. (In a film this is when the camera usually goes in for a close-up of the actor's face, because at this very point we want to see the change, to see what is happening behind the eyes.)

When a character enters a scene, the greater the disparity between what the character expects will happen and what actually happens the greater the sense of surprise. A good approach to creating an arc in a scene is to read through it several times, look at how the scene ends, and have your character anticipate, at the start, the exact opposite.

As Uta Hagen reminds us, the final part of scoring your scene is to ask yourself: does your character achieve the objective at the end of a scene; do they get what they want? If so, what do they do next? What happens if they don't get what they want? What will they do? Answering these questions will determine your character's next objective and will propel your character into the next scene. This chain of events shapes and defines the overall arc of the play as well as your character's through line or journey.

Developing Your Score

In the process of understanding this basic terminology and applying it to the character you are playing, you are discovering the essential elements of scoring a script. Remember: a play performed on the stage carries with it more than mere text, more than the lines on the page. Every actor must interpret the text by identifying, from one moment to the next, the psychological architecture of the script—the factors that live underneath the text and inform and color what you are saying.

In the worksheet that follows you will isolate and identify the elements that define your character's journey in a specific scene. This will help you pinpoint the essential emotional and psychological information that lives beneath the dialogue, determines much of your character's behavior, and adds depth and drama to your portrayal.

Worksheet

Scoring a Script

Play:

August : Osage County

Playwright:

Tracy Letts

Character:

Barbara Fordham

Age:

46 years old

Relationship to Receiver:

Daughter

Given Circumstances:

Bev missing, just arrived from Colorado, set in dining room, trying to understand what happened before Bev left

Place/Time/Weather:

country home outside Pawhuska, Oklahoma, August 2007, sunny ??

Relationships:

Antecedent Action/Beat:

B was the first to leave, V had drug problem in past,
V is bitter (?) that B left, Ben missing

Obstacles:

V is stubborn, blaming

Character Expectations: (What do you hope will happen in this scene? Don't anticipate the real ending; instead, incorporate what your character's expectations would be.)

Objective: I need to _____ in order for me to
(Rewrite until the stakes elevate this objective above all else.)

Actions/Tactics: I want to make him/her feel

Scene Reversals: (Find the boos and yeas within the scene; if the scene begins with yea then it should end with a boo.)

The Event (the It): (This usually occurs towards the end of a scene. What conditions exist now but were absent when the scene began?)

Subsequent Objective: What do you do when you get what you want? What do you do when you don't get what you want?

Chapter 3

The Actor's Warm-Up: Body, Voice, Mind

> Perfect communication for the actor implies a balanced quartet of
> intellect and emotion, body and voice—a quartet in which no
> one instrument compensates with its strength for the weakness
> of another.
>
> Kristen Linklater

Like an athlete, dancer, or musician, an actor must elevate their body,
voice, and mind from ordinary, everyday use to a higher performance
level. A warm-up is done before rehearsal or a performance. It is a
process that is geared to the individual needs of your instrument
(voice and body), as well as the specialized demands of a role.
Therefore, your warm-up adapts to meet the needs of each acting
experience. You should feel energized and focused after a warm-up;
ready for the audition, rehearsal, or performance.

Before you begin a warm-up, either you or the instructor should ask the following questions: How do you feel today? Not only physically (tired, hyper, achy, stiff), but also how are you mentally (tense, distracted, bleary, sharp, etc.)? Do you have any physical obstacles including injuries or illness that require accommodation? Is there a particular area that needs focus today? Is my voice connected to my body? Finally, acknowledge how you feel in the space and with the other members of the class. With the guidance of the instructor or ensemble leader, you should feel both comfortable and safe. It is important to be honest and recognize that your physical, mental, and emotional state changes from day to day and, therefore, you will need to adjust your warm-up for those conditions.

These warm-ups are for you; they are not about impressing others or your instructor. Warm-ups ultimately help to focus your area of concentration, both physically and mentally, as we will define in the following areas of concentration/focus:

Area 1: You, yourself alone in your immediate environment

Area 2: You and one other acting partner in a confined area

Area 3: You and the entire ensemble in the entire work space.

It is best to move from *Area 1* to *Area 2* to *Area 3* in group warm-up/work-out. Class will usually start in *Area 1* by focusing your breathing, relaxing your body, and releasing the tension and stress that has accumulated during your day. From *Area 1*, you are ready to start interacting with the ensemble as you move through *Areas 2* and *3* with group ensemble-building exercises and games.

At the beginning of every class, your leader will structure a variety of warm-up exercises. A routine will soon be established within a few

weeks into the course. You will be exposed to a variety of techniques and exercises; at the end of this chapter is a worksheet for you to note those activities that worked well for you. This is the start of creating a personal warm-up routine that can be applied to any acting situation.

In some university or ensemble theatre settings, the director, or an actor appointed by the director, will lead the cast in warm-ups, but in professional theatre, each actor is responsible for an appropriate individual warm-up before every rehearsal or performance. This chapter will help you establish an effective personal warm-up process that will evolve as you continue your training.

The actor's warm-up involves the body, voice, and mind. Many times a particular exercise will address two or more of these aspects at the same time. These exercises are also intended to stimulate the actor's imagination. The actor must have the imaginative aptitude of a child. The adult imagination is often difficult to access and kindle, but young children have a free and open access to the imagination. Children create "imaginary friends" and create pretend worlds with other children. A child has the ability to suspend their disbelief. As adults this effortless ability to access the imagination is inhibited by the necessity to navigate in the "real" world. Children start school, must learn facts, learn to communicate with others, and, of course, pay attention! Daydreaming is discouraged and, from school age onward, the use of imagination is too often discouraged.

As you explore this essential aspect of the actor's craft, remind yourself that each "game" or time of "play" in class is actually an opportunity to exercise your rusty young adult imagination.

An actor should begin by focusing their attention and concentration (*Area I*) on stretching and expanding their body and voice. This

physical warm-up should include relaxation, limbering, and energiz-
ing. But your focus is inward, and you are concentrating on the task
of isolating the various aspects of your instrument. One of the great
benefits of *Area 2* is that the focus now moves to you and your part-
ner. *Area 3* affords the opportunity to become a company and an
ensemble as your focus expands to the entire acting space and
company.

Being receptive and adjusting to each other in a spatial relationship
as well as to the layout of the space makes your movement onstage
more fluid and inventive. A shared trust that inevitably leads to a
shared bond begins to happen effortlessly.

After a thorough physical warm-up, the actor must then ready his
or her voice for the particular demands of the role. The techniques
described in this book focus on the non-singing voice for the stage
actor. Your vocal workout will adjust depending on the text you are
navigating (Shakespeare's heightened language has different demands
than if you are working on a contemporary play) and the stage con-
figuration or *venue* (a small, intimate theatre versus a large prosce-
nium stage or an outdoor space). All of these variables need slightly
different vocal approaches. Whatever your workout, be sure to address
breath, resonance, placement, and articulation.

The last part of this warm-up model is to acquire mental acuity
and focus. Group games are a great tool to tune-up your mental mus-
cularity. Participate fully in every exercise or game and you will find
yourself more energized and alert. In the back of this book is a list of
excellent sources for warm-up activities that should be part of any seri-
ous actor's library.

Physical Warm-up

A good warm-up is eclectic and incorporates approaches from master teachers and directors such as Anne Bogart, Rudolf Laban, Jerzy Grotowski, Tadashi Suzuki, and Viola Spolin. The physical warm-up should usually begin with some aerobic, stretching, and limbering exercises and will often include working with a partner or group. Anne Bogart, Artistic Director of SITI Company, cofounded by Japanese teacher/director Tadashi Suzuki, has developed one of the most popular and successful methods of physical training. Bogart has developed a holistic dance-inspired approach to physical, vocal, and mental training for actors called Viewpoints. She describes the core ideas behind her exercises: "Viewpoints is a philosophy translated into a technique for (1) training performers; (2) building ensemble; and (3) creating movement for the stage. . . . a set of names given to certain principles of movement through time and space . . ." (Bogart and Landau, 7–8).

The Viewpoints of Time include:

- Tempo (how fast or slow a movement or moment is on stage)

- Levels (utilizing your linear body in space; for example, tall on tiptoes or compressed and close to the ground)

- Direction (cutting through space directionally to create dynamic vectors)

- Duration (how long a movement or moment continues uninterrupted)

- Kinesthetic response (a spontaneous physical reaction to stimuli outside of yourself)

The Viewpoints of Space include:

- Gesture (a movement using various parts of the body that has a beginning and end)

- Shape (the outline the body or bodies make in space)

- Topography (the floor pattern created by movement in space)

Viewpoints provide the foundation for a variety of individual and group physical exercises and improvisations used in preparation for rehearsal and performance. Fully investing in the Viewpoints process or any strong physical activity releases in the actor a heightened awareness of his or her body in relation to other bodies and in relation to the working space. Sometimes you will find that working in this technical and physical way inspires your imagination and evokes all sorts of emotional responses that are often surprising.

This sort of physical work creates an awareness of the countless possibilities available to the actor at any moment onstage, but also encourages the freedom to let go and trust the moment, not to plan or manipulate it. These exercises will test your own capacity for spontaneity.

Here is a movement sequence that employs a variety of Viewpoints.

Movement in Space

You will be moving in the space on a premeditated floor pattern. Today, this floor pattern is a grid of horizontal and vertical lines intersecting at 90-degree angles. Imagine the floor as a large piece of graph

paper. The instructor will give you a signal, and you will start to move on this grid pattern, following it precisely, perhaps from top to bottom or the reverse. Move naturally but purposefully. You may feel a little self-conscious at first. This is natural, but remember that actors desire the audience to watch them and this is the first step in cultivating that ability to make the audience watch you! So avoid looking down, hunching your shoulders, giggling, shuffling your feet, or any other self-conscious behavior that signals fear or insecurities.

Move through the space avoiding physical or visual contact with the other actors. Once you are comfortable doing this, the instructor will introduce some adjustments. You can change the *tempo* of your movement from quick to super-slow; you can change *levels,* from tip-toe to slithering on the floor; you can change *direction,* move forward, sideways, and back. Work with *duration,* or how long you stay in a particular tempo or movement. If you find yourself constantly chang-ing your movement, perhaps you need to linger in a particular spot (*viewpoint*) for longer than is comfortable.

If you find your mind wandering while doing this exercise, it may be time to switch it up and explore a different tempo, direction, or level. Challenge yourself as you move—explore *extremes.* Move with extreme slowness—so slow it is barely visible—then work in "hyper-speed." Embrace the space with velocity!

Now follow another student, repeating/mirroring their tempo, direction, or level. You may repeat off the movements of another stu-dent from a distance, choosing perhaps to replicate their direction or tempo. One of the benefits of following another person is that you break your own habitual rhythms, and now you are only obligated to "receive" and "react."

You are not expected to be interesting or inventive; you merely should follow the instructions as precisely as possible and let go. This is NOT a performance but a warm-up. Shut out the voices in your head that are judging and commenting, and throw yourself into the simplicity of this physical action.

Voice

In both stage and screen, your voice is your greatest asset. A grounded, unaffected, and flexible voice may not only land you lucrative voiceover work, but also is an essential component to any successful career.

The connection of the body to voice production is emphasized by renowned voice teacher Kristen Linklater: "The first step, then, in freeing the voice, in getting acquainted with your spine." Before attempting any voice work, it is important to align the spine in an exercise called the "rag doll" or "puppet."

Aligning the Spine

Stand with your feet shoulder-width apart, equally balanced. Your knees should be soft, shoulders relaxed, and arms by your sides. Check for any unnecessary tension in your body. Release that tension by speaking it *out*. For example, "My jaw is tense," or "I am clenching my fists." Begin with some slow, easy head rolls. After a few rotations, let your head hang from your neck with your chin on your chest. Allow the gravity of your head to pull your spine down to the floor. Keep your knees soft as each vertebra unfolds. Go as far as you are com-

fortable or able and hang over for a few minutes feeling the stretch in the upper and lower back and the expansion of the rib cage. Breathe into this stretch using abdominal muscle to support you as you begin to slowly rebuild the spine, vertebra by vertebra, allowing the shoulders to fall back into place and finally the head to float like a helium balloon. Repeat this exercise slowly and attentively and you will feel a change in your alignment. This physical change will aid you in breath and voice production.

Breath is the foundation of all sound production and should be the focus after physical alignment. It not only prepares the voice but also energizes the body.

Breath is the inhalation and exhalation of air. If too little air is released when speaking, the voice can sound strident or harsh. If too much air is released, the voice sounds breathy and thin.

When you breathe in, air and other gasses travel down the windpipe, and the windpipe divides into two as it enters the two lungs. The two pipes divide and subdivide more than twenty times into smaller and smaller tubes, which eventually end in groups of little sacs called alveoli. There are about 300 million of them in your lungs and they are surrounded by tiny blood vessels. The alveoli act as the primary gas exchange units of the lungs where the exchange of oxygen and carbon dioxide takes place.

The lungs are merely the receptacle for the inhaled air and are attached to a structure of muscle and bone that helps bring oxygen into the lungs. The diaphragm is the chief muscle used in respiration. A large, flat muscle situated between the organs of your chest (heart and lungs) and the organs of your abdomen (stomach, liver, intestines), the diaphragm has two flexible domes connected by a central

tendon. The rim of the diaphragm attaches to the bottom of the sternum (breastbone) at the front and around the lower ribs at the sides.

When you inhale, the diaphragm contracts and the domes are pulled down and flattened. Visually, you will notice your belly expand as well as your rib cage. When you exhale, you will notice the diaphragm pulling back towards the spine.

Visualizing this physiognomy will help you attain focused or conscious breathing in order to clear the mind, relax the body, and expand your vocal range.

Focused Breathing

Take a few minutes and get into a comfortable standing position—feet shoulder-width apart, knees soft (not locked), arms hanging at your sides, shoulders relaxed, and chin parallel to the floor. Then close your eyes and take a relaxed full breath in through the nose and release that breath through the mouth. Do not force your breath, but continue to inhale and exhale effortlessly for a few minutes. Allow your thoughts to focus only on the breath entering your body and leaving your body. This focused breathing is an excellent tool to help clear your mind whenever you feel overwhelmed, tense, or mentally scattered.

Now think of the quality of your breath. Are you breathing in gulps of air through the mouth that cause your shoulders to rise up, or are you inhaling deep breaths through the nose allowing an expansion of the belly and ribcage? If you feel your shoulders rising, you are probably taking shallow chest breaths that can't adequately support the production of sound. Place your hand on your belly just below the ribcage and breath in deeply through the nose; you will notice the

belly expand, and as you exhale through the mouth, the belly flattens although it doesn't collapse. This is what a diaphragmatic breath feels like, and this is the breath that will give you the maximum capacity and support for speaking on stage.

Straw Breathing

This exercise can be done either standing or lying on the floor. It is an easy way to identify the feeling and quality of a diaphragmatic breath. Take a drinking straw and put it in your mouth. Place your other hand on your belly just below the ribcage. Take five sips from the straw and blow out of the straw in a steady stream of air, as if you were blowing out birthday candles. Repeat a few times and then try breathing without the straw. Sip in five breathes and release in a steady, focused stream of air.

Projection

Actors must be heard on stage so their voices must be projected appropriate to the space. While it is critical that the actor be easily heard by every single member of the audience, the admonishment to "speak louder" or "project" may result in misusing the voice by shouting and straining the throat muscles. This is a danger for the less-experienced actor. However, if the actor, instead of trying to speak louder, fully understands and internalizes the needs of the character while raising the stakes appropriate to the moment, he or she will be heard. If you connect your voice to action, you will have an active voice that is supported by breath and projected. Avant-garde acting teacher and

director, Jerzy Grotowski, created the following effective exercise to help the actor connect to a spontaneous, well-placed, and appropriately amplified voice. In his book, *Towards a Poor Theatre*, Grotowski describes an "organic" method of actor training that includes vocal work. This organic approach leads the actor to be less self-conscious about how their voice sounds and not to rely on superficial adjustments in order to produce a synthetic, pleasing voice. This exercise is characteristic of his technique and develops spontaneous rather than premeditated vocal reactions.

Projection Exercise

In the beginning you should apply sound, not words, to these commands. The sounds you use may be made of vowels and consonants. Use your voice to make a hole in the wall, to overturn a chair, to put out a candle, to float a balloon, to caress, to pinch, to push, to wrap up an object, to sweep the floor; use the voice as if it were an axe, a hand, a hammer, a pair of scissors, or a silk scarf. Incorporate the action words as text, as you let these words trigger different vocal qualities; for example, "I am slapping you with my voice. I am pushing you with my voice. I am slicing you with my voice." Embrace the onomatopoetic nature of the physical actions, the idea that words often sound like their meaning and, therefore, may inspire greater range and color.

Articulation

In addition to being heard, the actor must be understood. The sounds that make up language must be clearly and accurately enunciated. For

example, although students from the west coast of the United States aren't known to have a distinct dialect, one often detects an underlying cadence to their speech that subverts clear diction and strong actions because of the inclination to uplift the end of a statement as though it were a question. There is also a tendency to swallow the ends of words, particularly the final consonants. The following exercise forces you to attack the word, open your mouth wide for the vowel, and articulate the end consonant. Use your articulators—the tip of the tongue, the teeth, and the lips—to grab and use the language as you land the meaning of each word.

Articulation "A-E-I-O-U"

Billy Whitelaw, in order to navigate the many plays she performed by Samuel Beckett—plays filled with words and rapidly paced—developed the following exercise for improving articulation (notice that the sequence is: spell the word, then say the word, then build upon the previous words in rapid succession making sure the individual sounds are distinct):

P-A-T, pat

P-E-T, pet, pat, pet

P-I-T, pit, pat, pet, pit

P-O-T, pot, pat, pet, pit, pot

P-U-T, pat, pet, pit, pot, put

Repeat in rapid succession.

Physicalizing Text

Hungarian modern-dance teacher Rudolf Laban combines the physical and the vocal in the following inventive and challenging exercise. This is an extension of the Viewpoints exercise from earlier in this chapter. While moving along the grid or any floor pattern, you will be instructed to modify your movement in a variety of ways: miming hitting a nail with a hammer, snapping a towel at someone, stretching an elastic band, or scattering seeds. With each adjustment you should be conscious of the modifications your body makes in response to the new stimuli. What is the amount of physical exertion? How do you use the space with your body and gestures? How is time used (steady or pulsing)? Now you will add sound to the exercise. For example, while snapping the towel, vocalize that famous quote from Shakespeare's *Hamlet:* "To be or not to be that is the question." Do the same thing with hitting a nail, stretching an elastic band, etc. Be aware of the vocal changes that occur with each new modification. How do pitch, volume, inflection, and stress change? Be aware of your own physical and vocal changes in response to the exercise, but also observe and listen to the other students in the class. Oftentimes, observing an exercise done by others can be as much of a learning experience as doing it yourself.

The Mind: Transformational Excercises

One of the best ways to expand your imagination is through transformational exercises. The more you permit outside stimuli to elicit your next inspired response, the more comfortable you become with imaginative play.

Try this exercise. In a circle, a plain silk scarf will be passed from actor to actor. When you receive this scarf it is your job to transform it into something else. For example, the scarf can be rolled up into a ball and you can pantomime taking a bite out of it; it has become an apple. Next it becomes a violin held taut between your chin and fist as you mime an imaginary bow, or it can become long flowing hair that you are brushing before going to bed, etc. Transformation exercises fortify your creative imagination and demand a commitment and belief in your imaginary circumstances. When an actor fully believes in the given circumstances, so will the audience.

The actor is responsible for being physically, vocally, and mentally prepared for both rehearsal and performance. It takes discipline and is the mark of a professional actor. Following is a worksheet that you can utilize to record those exercises that best address your individual needs.

* Warm-up is important & beneficial because...

* how I felt/feel about exercises we have done in class so far

Worksheet

Your Personal Actor Warm-up

Physical

Aerobic Exercises (Get the heart rate pumping, and wake up the body.):

Limbering and Stretching Exercises (After some aerobic work, it is essential to stretch the muscles. Target areas should be neck, shoulders, back, and hips.):

Focused Breathing

Stand with your weight equally distributed on both feet. Sit as though you have an imaginary stool under your bottom, bring your fingertips together, exhale, then inhale and bring your arms up, allowing the rib cage to remain elevated. Repeat, allowing the breath to be released slowly and the rib cage to remain elevated with shoulders relaxed and down.

Other Breath Exercises

Vocal Resonance and Articulation

Vocal Exercises

B - D - G (say ^{letter sounds} slow then fast)

P - T - K

oo - ee - oo - aa

impros - can help with imagination
- you create the circumstances

Chapter 4

Improvisation and the Contentless-Open Scene

> Everyone can act. Everyone can improvise. Anyone who wishes to can play in the theatre and learn to become "stage worthy."
>
> Viola Spolin

Developing a safe and inspiring environment is more important to the acting process than one could ever imagine. Through theatre games and improvisation techniques, even if it is just you and a partner, a veritable acting ensemble will emerge. The more fun you can have, the more creative you become, and the better you will be able to act on your feet and stay in the moment. A class that trains together develops routines that permit theatrical play and improvisation to happen quickly and without editing or censoring impulses. The key to a successful ensemble is complete spontaneity.

When we think of improvisation, we think first of Viola Spolin, who died in 1994, but is still considered the Grand Mother of Improvisation. Spolin influenced the first generation of improvisation at the Second City in Chicago in the late 50s, as her son, Paul Sills, was one of the co-founders. She was one of the first theatre artists to develop specific games for actors that would focus on creativity and help to free an actor's individual capacity for creative self-expression. Her games, which have become classics for all improvisation building, can be found in her book *Improvisation for the Theatre.* Keith Johnstone's book *Impro* is also an excellent source book for those interested in improvisation. His book discusses basic improv theory and looks at the nature of spontaneity. Freeing you to be spontaneous and building spontaneity in the context of an ensemble is essentially the goal of all creative dramatics and theater games.

The following are some games and improvisational starters that have been used in many acting studios to spark an actor's creativity.

- Try improvising a situation (who you are, where you are, what you are doing, and why you are doing it) using only gibberish as a form of communication, but specify your meaning so that the class understands the context even without understanding the language.

- Play a scene with only two words—for example "yes" or "no"—or a nonsensical phrase such as "the sky is green." Imbue it with meaning and *subtext.*

- Play a game of tennis with an imaginary ball and racquet but stay true to the score. Support your partner but play the game specifically: when is the ball in or out, who got the point, did the ball hit the net?

- Another popular exercise is the *mirror game*. Stand facing your partner and mirror their every move and see if you can intuit their impulses. Eventually both of you are moving as one—mirror and reflection.

- Begin an improvisation as physically as possible. When your instructor calls out "Justify!" you will freeze in position and begin a new improvisation with a new justification for your physicalization.

Improvisations are designed to help you return to an earlier, innocent time of creative play. Through improvisations, you learn to trust and embrace your creative impulses without censoring them.

Jumps: A Technique for Exploring Objectives and Actions

"just do it!"

The improvisation technique called "Jumps" (featured in this section) is designed to return you to an earlier, innocent time so that you can speedily sidestep your urge to censor your freer, more creative impulses. "Jumps" refers to the command to *jump* into your improvisation without fear of humiliation, rejection, or adverse consequences, and without forethought or premeditation that might otherwise allow self-criticism to hamper your performance.

The following exercise illustrates one way in which the Jumps improvisation, developed by Lew Paulter, can aid the actor in exploring the concepts of objective, actions, and obstacle with a partner. For this exercise, Actor A sits on stage knowing nothing whatsoever of the given circumstances. Actor B enters the space knowing exactly who he or she is, what he or she wants, and the relationship he or she has

with Actor A. Actor B must phrase the first line of the improvisation to clearly and directly indicate the objective. Actor A must figure out who Actor B is by Actor B's character and interaction with Actor A. If Actor B is clear about the relationship and given circumstances, it will be obvious in the improvisation.

For example: Actor B says, "Oh my God! You're late for school! Get in the car, I have to be at work in 15 minutes!" Actor A must now intuit their relationship and immediately form an <u>antithetical objective</u> <u>(obstacle)</u> to Actor B; for example, Actor A might respond, "It is always about your job. I hate school, I hate my life, and I am not going in today! Why can't you care about somebody else for a change?!"

Now the improvisation is ready to become a tennis match as each actor uses a variety of actions. For example, Actor A makes Mom—Actor B—feel guilty, worried, ashamed. If you are playing Mom, make your child—Actor A—feel guilty, threatened, ashamed, or perhaps cajoled, motivated, or bribed! Each tries to get what they want, to achieve their objective.

The *playing* of your actions, as you pursue each of your objectives, will help you be in the present with your scene partner. Jumps helps you internalize what it feels like to attack an objective by playing actions, by making your partner feel _____, line by line, moment by moment.

As an improvising technique, <u>Jumps help you to think fast and on your feet.</u> It is not about script writing or mitigating a situation through clever text in an effort to win your objective; it is about honestly going after what you need with total commitment, a lack of self-consciousness, and a focus on what you are doing to the other person to get him/her to give you what you want.

Jumps also helps you understand that behavior defines character. The actions you play reveal, to an audience, the kind of person your character is. For example, as Actor B, the mom who is late for work and must get her child to school, your actions might make your child feel ashamed, humiliated, embarrassed, or threatened. This tells us something about the kind of mother you are. The same objective (to get the child to school so you are not late) could inspire very different actions. You might try to make your child feel understood, placated, loved, or consoled.

A different approach to the same objective reveals a different character and a very different mom.

The impact of Jumps should not to be undervalued. Hours can be spent on this skill-building technique as you and your partner continue to explore the dynamics and drama that come from the obstacles you create for one another. Drama resides in the antithetical objectives (obstacles). Remember, in Jumps, text is not important and should be minimal. What matters are the actions you play as you make each other feel _____ in order to pursue and achieve your objectives.

Some reminders while improvising:

- Listen to your partner.

- Respond to what your partner gives you. (Don't attempt to direct each other; let yourself be surprised by your partner. Surprise is the key to improvisation.)

- Stay in the moment.

- Don't push for laughs. (Improvisation technique is not about being funny or clever; it is about pursuing your *objective* with your heart and soul.)

- Embody—*physicalize*—your reactions. (Don't be afraid of the impulse to move and physically use space around you.)

- *Do, rather than feel,* and let that surprise *even* you.

- Unpredictability is the key to invention. (Don't try to control the moment; let yourself go and trust your partner to return the ball.)

- Always support the agreed-upon reality. (Don't change the unspoken given circumstances mid-stream.)

- Commit totally to your objective and don't give up on that pursuit.

- Finally, work with passion and enjoy the challenge.

Contentless-Open Scene for Improvising Given Circumstances

Now that you have become more comfortable thinking on your feet and creating your own text, try improvising the given circumstances without being encumbered by text. Again, given circumstances are the facts and conditions that inform the meaning of the text. A simple line of text can have hundreds of meanings depending on the facts and conditions informing, inciting, or inspiring that text.

For example, take the text "I love you." The meaning changes if you are young and in love and speaking to your boyfriend in whom you have complete trust and confidence; *or* if you are speaking to your elderly and sick grandmother, and you are about to leave for college and possibly never see her again; *or* if you are speaking to your agent, whom you don't trust or like, and say the line as a cover while ending the conversation on the phone.

In each scenario that follows, the text remains the same and yet the meaning is completely different because of the facts and conditions surrounding and informing the text. We call this the given circumstances, in that whenever you speak a line of text it must be informed by the circumstances. In improvisation you invent the circumstances; in a play they already exist. This is why you must always read the entire play before performing a scene or a monologue from it. Without a context for your lines there is no meaning.

The following simple contentless scene allows you to be as inventive and original as possible. We supply the text; you must supply the relationships, antecedent beat, objectives, and tactics. For your improvisation to succeed, your partner must provide a strong obstacle to your objective!

With a partner memorize these few lines:

A. Ah.

B. So?

A. All set?

B. Umm . . . no.

A. Well. . .

B. Let's go.

Decide together the "who, what, where, when, and why" of the given circumstances. Who are you, what is your relationship to each other? What are you doing? Where are you doing it? When, what time of day, year, etc., are you doing it? And, finally, why are you doing it? The more urgently you perceive your objective, the more dynamic this mini-scene will be. Also the more you and your partner fill in these details, without explicitly stating your given circumstances, the better

everything will *read* (be conveyed). If you are aware of the given circumstances, they will be conveyed to the audience.

Think outside the box in your invention of the given circumstances. Are you game hunters in Africa, astronauts before a countdown, a surgeon operating on his own mother, or a prison guard pulling the switch on the electric chair? The more willing you are to move outside your own safe and limited circumstances, the more fun this will be. Like any muscle your creative imagination must be continually exercised if you are to succeed as an actor.

Now create a "who, what, where, when, why" improvisation, making up your dialogue on the spot. By answering these five questions (the *five Ws*) in as much detail as possible, you will find your dialogue will flow naturally and spontaneously as you each pursue your objectives, creating obstacles for each other.

With your same improvisation partner, choose one of the following contentless scenes for your first duo scene performance. Because there is no script to provide you with the given circumstances and the particulars surrounding the world of the play, you and your partner must now invent those details. Again the more specific your combined understanding of this situation is, the more nuanced and colorful the details you create are, the stronger your scene will play.

Contentless-Open Scene 1

A: Hmmm . . .

B: Well?

A: I just don't know . . .

B: But -

A: Just wait!

B: I can't!

A: You are always like this.

B: Like what?

A: Like . . . ahhh, forget it.

B: I think you are afraid.

A: Yeah, right!

B: I do.

A: Think what you want. I'm going.

B: You are?

A: Yeah, wanna come with me?

B: I don't know . . .

A: I'm waiting.

B: Okay, I'll come with you, but I'm going first.

Contentless-Open Scene 2

A: What's up?!

B: Hey. What's going on?

A: You know, okay.

B: Why didn't you answer my text?

A: I've been. . . I mean . . .

B: Right. You got a lot on your plate.

A: It's just with work and stuff. I've been busy lately.

B: Whatever.

A: Well, I'd better go.

B: Where's the fire?

A: Stop being a jerk.

B: Okay, come back. Can I help you with this?

A: No, no thanks. You've done enough.

B: That's what I'm saying.

A: What are you making?

B: My great escape.

Contentless-Open Scene 3

A: Did you find him?

B: No, how are you doing?

A: Better than I look.

B: Great. What do you want to eat?

A: Whatever.

B: Let me fix you something.

A: Whatever. Are you going to go to work?

B: I'd better.

A: Right.

B: Do you want me to stay?

A: It's up to you.

B: I just can't.

A: Like I said. It's up to you. So where did you look?

B: Everywhere.

A: Did you try Denny's?

B: No. I forgot.

A: Why didn't you . . . go to the . . .

B: I guess I thought he'd call.

A: You guess?!

B: Well, then I made a mistake.

A: I'll say.

Contentless-Open Scene 4

A: Who are you?

B: I think you know.

C: Oh?

B: Yes.

A: Why are you doing this?

B: It's the best thing.

C: What does this mean?

A: I know as much as you know. Just tell me what you want.

C: Let's get out of here. This isn't going to serve any of us.

B: Trust me, you'll live to regret this.

A: Wait, what's going on here? Do you know each other?

C: No. Listen this isn't the time.

A: What does this mean?

C: Nothing.

B: I wouldn't try that if I were you. In fact, you have 'til the count of three . . . one . . .

A: You're good.

C: Maybe we should try to work this out.

B: Two . . .

A: Listen -

C: Forget it, we've done nothing wrong.

B: Nothing? Gimme a break. You know exactly why we're all here. And you're both running out of time.

A: I'm out of here.

C: Forget it . . .

B: Three . . .

Preparing Your Contentless-Open Scenes for Performance

I. Select a script with your scene partner. Construct a plot, *given circumstances,* and *antecedent action.* Answer the following questions:

 • Who are these people; what is their relationship?

 • Where and when does the action of the scene take place?

 • What are the characters doing?

 • What is each character's objective?

- How do they try to achieve their objective? (what are their actions?)

- What is the obstacle?

2. Decide what character each of you will play. Once you and your partner have brainstormed together to invent the details surrounding the given circumstances of your scene, apply Stanislavski's magic If. If these given circumstances that you and your partner have invented were truly your own, how would you feel? How would you behave? Truthfully reacting to the circumstances as if they were your own will make your scene vivid and distinct. Create a written character analysis by answering the following questions from acting teacher Uta Hagen's *Respect for Acting*:

 - Who am I? What is my state of being? How do I perceive myself? What am I wearing?

 - What are the circumstances? What time is it (year, season, day)? What time does the scene begin? Where am I (country, city, neighborhood, building, room, landscape)?

 - What are my relationships?

 - What do I want? What is my objective?

 - What is my obstacle? What gets in the way of what I want? How do I overcome it?

 - What do I do to get what I want? What actions do I employ to get what I want? What do I do when I get or don't get what I want?

 - What is my back story? (my age, marital status, education, economic station, etc.)

3. With your partner, devise a ground plan. Make sure you have a clear sense of where the entrances or exits are and a clear understanding of the architecture you inhabit. One chair does not a living room make. Remember to give the space specific anchors that will help motivate and contain how you have blocked the scene.

4. First Rehearsal:

 • Read the scene aloud several times.

 • Make sure each of you have an objective for the scene and have answered the previous questions completely.

 • Now get on your feet. *Play* the scene organically, moving on impulse.

 • Plan your next rehearsal and include your *secondary activity*. A character's secondary activity is any activity or *stage business*, arbitrary or related to the scene, that your character might be doing in the context of the scene. For example, cooking dinner, knitting, putting on make-up, etc.

 • Figure out any set, costume, or props needed and who will be responsible for them. Also think about the use of music in the scene.

5. Second Rehearsal:

 • Lines should be memorized at this point, so run your dialogue with your scene partner so that you both feel secure.

- Finalize blocking, make any adjustments, and incorporate any new ideas.

- Run the scene several times.

6. Third "Dress Rehearsal":

- Bring all necessary set items, props, music (always a good idea!), and costumes.

- Run the scene once to make adjustments for these additions.

- Run it several times at "performance level" to understand the demands needed on the day of your final performance.

7. Final Performance:

- Come prepared with all necessary props, costumes, music, and equipment.

- Plan your stage set up to be as authentic as possible.

- Hand in your plot analysis, ground plan, and each actor's individual character analysis.

- Commit to your preparation, your scene, and your partner. Don't rush!

- Break a leg! ("Break a leg!" is the actor's "Good luck!" Actors, traditionally superstitious by nature, used to believe—and some still do—that wishing someone bad luck courts good luck, and wishing someone good luck courts bad luck. "Break a leg" remains a nearly universal pre-show ritual greeting in the theatre today.)

Chapter 5

Scene Study: The Duo Scene

★ I am enough of an artist to draw freely upon my imagination. Imagination is more important than knowledge. Knowledge is limited. Imagination encircles the world.

Albert Einstein

Analyzing Your Scene

A scene is a microcosm of an entire play, and like any good dramatic work it needs to begin differently than it ends, and there needs to be an event, a turning point, that triggers this change. When you read your scene, note how it ends. If you think of a scene as a series of reversals (yeas and boos), then notice if the scene ends with a yea or a boo for your character. You will most likely enter the scene with an objective (what you want from your partner in the scene). At the end

of the scene, did you get what you wanted? Did you achieve your objective or not? The answer will tell you if you ended on a yea or a boo. Now get as far away from the ending as the text will allow so that you can perceive that the scene has a shape and a clear event (the It). The event of a scene is tantamount to the climax of a play; it is the turning point of your scene that effects a change for your character. What condition or state of being has changed in this moment, which usually comes close to, or at, the very end of the scene. Write this down. Notating the changes or shifts (i.e., the reversals) beat by beat, moment to moment, is called scoring your script.

Like music, the text needs to be shaped and annotated with your objective, actions, reversals (yeas and boos), and the event (the It). Your It determines how your scene will end and, most importantly, if you have attained your objective. Inform your objective with urgency and with high stakes.

Punctuation and Subtext

When analyzing your scene look carefully at how the text is punctuated. Punctuation (like grammar) not only informs the real meaning behind the text but also defines the way your character thinks, where they come from, their socioeconomic status, and the psychology that informs their thought process and their mode of communicating. When punctuation seems odd (e.g., a one-word sentence or an ellipsis) your job is to analyze and fill that punctuation. By fill we mean to find the logic and intention behind the text that justifies the unusual/specific punctuation. For example, the sentence, "No. I can't go." is different from "No, I can't go." In the first sentence the char-

acter does not start out saying, "I can't go," only, "No." Only then is the "I can't go" uttered. This is very different from the all-in-one thought, "No, I can't go." By changing the period after "no" to a comma, you actually alter the logic—the psycholinguistics behind your character's thinking. In analyzing the original punctuation, you discover your character's rhythm and personality. Avoid correcting or normalizing grammar or punctuation and remember this is a precise tool the playwright is using to define a particular character. Don't fix the punctuation or grammar if it seems unusual or grammatically incorrect—fill it. Incorporate it into your characterization.

Quite simply, a period lands the thought and usually accompanies a downward inflection of the voice, a comma is a continuation of your earlier statement, and an ellipsis or dash generally means that your thought is interrupted by another character. Exclamation points are a playwright's way of raising the stakes and should be respected. By the same token, do not add exclamation points (and the corresponding vocal emphasis) if the author has not punctuated the scene to express that agitation. There are many ways for the actor to be strong, angry, tyrannical, or raise the stakes in the scene without raising your voice.

The character's word choices (or speech patterns) will reveal a great deal. Pay close attention to the words your character uses and the speech patterns that define the way she or he communicates. Are they aggressive? Passive? East coast or west coast? Do the characters finish their thoughts and choose their words carefully or constantly interrupt themselves or others with the next idea?

The character's dialogue and speech patterns reveal the subtext and interior meaning that is motivating and justifying what they actually say—the text. In real life, people rarely say what they mean, and so it is in a well-written play. It is the discrepancy between what we

mean and what we say that creates dynamics within a scene and for-
tifies the dramatic action. A side note: classical plays are often differ-
ent. In Shakespeare's plays, for example, characters can sometimes
mean exactly what they say and use their text to set the scene and tell
the story.

In this scene from Sarah Ruhl's *The Clean House*, it is the subtext
that is driving this seemingly uneventful encounter (Ruhl, 26–27).

Lane:	Oh! You startled me.
Matilde:	You startled me too.
Lane:	What are you doing in the dark?
Matilde:	I was trying to think up a joke. I almost had one. Now it's gone.
Lane:	Oh – well - can you get it back again?
Matilde:	I doubt it.
Lane:	Oh. Is Charles home?
Matilde:	No.
Lane:	Did he call?
Matilde:	No.
Lane:	Oh, well, he's probably just sleeping at the hospital.

What isn't stated is that Lane's husband is having an affair and
Matilde, her cleaning lady, senses the situation but chooses to avoid
exposing the truth in order to keep her job. The subtext (in parenthe-
ses) might go something like this:

Lane:	Oh! You startled me.
	(What is she doing sitting in my living room in the dark. Stealing?!)

Matilde: You startled me too.

 (What? You don't trust me?)

Lane: What are you doing in the dark?

 (This maid is getting on my nerves.)

Matilde: I was trying to think up a joke. I almost had one.
 Now it's gone.

 (Thanks to you!)

Lane: Oh – well - can you get it back again?

 (I wish she would just go away.)

Matilde: I doubt it.

 (I feel sorry for you.)

Lane: Oh. Is Charles home?

 (Does she know something?)

Matilde: No.

 (He's probably off screwing his patient! Do you really
 not know this?)

Lane: Did he call?

 (You know something.)

Matilde: No.

 (I'm not going down with this ship!)

Lane: Oh, well, he's probably just sleeping at the hospital.

 (Why hasn't he called or texted me like he used to?
 God, I want him back. What's happening to me?)

Both characters are clearly covering the truth from one another. Their unspoken secrets create the dramatic irony and energy of their interaction.

For the beginning actor the process of scoring a script is based on a careful reading of the entire play at least once, but ideally a couple of times. Your script is the map that will allow you to discover your character. In your first read determine the given circumstances and the basic story (who does what, with what, to whom, and why). Next, read the script from the point of view of your character. Look for information that will help you discover your objective and determine your actions. In addition to studying syntax, you should carefully examine the following elements:

- Stage directions

- What the characters say about themselves—the discrepancy (if any) between what they say and what they do

- What other characters say about your character

- What the characters do (actions and behavior)

All of this information will lead you to a greater understanding of your character and will help you, as your character, to determine your objective.

This is the foundation of your character analysis, and it is only after understanding what the playwright has provided that you can begin to fill in the gaps and glean the information necessary to fully realize your character in a way that is not found in the script. For example, the playwright will usually provide you with a name for your character but sometimes not give the age. That is information that you must infer or extrapolate based on the given circumstances provided in the text.

✭ Example of a Scored Script

Play:	*The Shape of Things* by Neil LaBute
Character:	Adam
Situation:	Final confrontation with girlfriend, <u>Evelyn.</u>
Objective 1:	I want to hurt Evelyn for what she did to me. (RAISE THE STAKES)
Objective 2:	I need to punish this bitch for humiliating me. (Note how *Objective 2* has more urgency and a greater visceral connection to his need.) (RAISE THE STAKES EVEN HIGHER)
Objective 3:	I need Evelyn to admit that she really loves me and to be sorry for destroying me.
Antecedent Action/Beat:	Adam has just been blindsided and publically humiliated by Evelyn's master's thesis presentation where she revealed that their relationship was nothing more than a "project" designed to gather data to support her thesis.
Adam:	Was any of it true?
Evelyn:	What do you mean?
Adam:	Not the things we did, or the kind words or whatever . . . but any of it?
Evelyn:	. . . no. not really.
Adam:	I mean about you. The nose-job or Lake Forest or your mother's maiden name? One thing you ever said to me?
Evelyn:	My mom's name is Anderson . . .

Adam:	Oh, are you twenty-five?
Evelyn:	Twenty-two. Just . . . I skipped third grade.
Adam:	Okay . . . (beat.) And the scars are . . .
Evelyn:	I made it all up.
Adam:	Got it. I got it . . . Gemini at least?
Evelyn:	No, Pisces. Sorry.
Adam:	Don't be. Hey, it's . . . art.
Evelyn:	I should probably get going, I gotta hook up with some guys from my department . . .
Adam:	Alright.
Evelyn:	. . . and I think the dean wants 'a word' with me, too. (*Ricky Ricardo voice*) 'I got some 'splaining to do.'
Adam:	What's that from?
Evelyn:	Nothing. *I Love Lucy.*
Adam:	Ahh, TV, that other great art form.
Evelyn:	Un-huh. You coming?
Adam:	Nah, not yet . . . don't worry, I'm not gonna do anything to your stuff. No spray paint. I just . . .
Evelyn:	I understand. Go ahead.
Adam:	Thanks.
Evelyn:	The door locks if you just close it.
Adam:	Great.

Evelyn smiles at him once more but says nothing. She heads for the door but stops.

Evelyn:	. . . that one time.
Adam:	Huh?
Evelyn:	In your bed, one night, when you leaned over and whispered in my ear . . . remember?
Adam:	'Course. I remember everything about us.
Evelyn:	And I whispered back to you, I said . . .
Adam:	I remember.
Evelyn:	I meant that. I did.
Adam:	Yeah?
Evelyn:	Yes.
Adam:	. . . oh.

She starts to say something else but catches herself. She goes out. Adam stands alone in the quiet room, looking out.

Following is the same scene only scored from Adam's point of view. Adam's actions are notes in parentheses and his reversals, his yeas and boos, are noted in italics on the right side of the dialogue. Remember that Adam's objective is: I need Evelyn to admit that she really loves me and to be sorry for destroying me.

(*Action:* make her feel ashamed)

Adam:	Was any of it true?	*BOO*
Evelyn:	What do you mean?	
Adam:	Not the things we did, or the kind words or whatever . . . but any of it?	

Evelyn: . . . no. not really.

(*Action:* expose her)

Adam: I mean about you. The nose-job or Lake Forest or
 your mother's maiden name? One thing you ever said
 to me?

Evelyn: My mom's name is Anderson . . .

Adam: Oh, are you twenty-five?

Evelyn: Twenty-two. Just . . . I skipped third grade.

(*Action:* make her feel humiliated)

Adam: Okay . . . (beat.) And the scars are . . .

Evelyn: I made it all up.

(*Action:* make her feel unimportant)

Adam: Got it. I got it . . . Gemini at least?

Evelyn: No, Pisces. Sorry.

(*Action:* belittle her)

Adam: Don't be. Hey, it's . . . art.

Evelyn: I should probably get going, I gotta hook up with
 some guys from my department . . .

Adam: Alright.

Evelyn: . . . and I think the dean wants 'a word' with me,
 too. (*Ricky Ricardo voice*) 'I got some 'splaining to
 do.'

(*Action:* keep her engaged)

Adam: What's that from?

Evelyn: Nothing. *I Love Lucy.*

(*Action:* make her feel stupid)

Adam: Ahh, TV, that other great art form.

Evelyn: Uh-huh. You coming? *YEA*

(*Action:* make her laugh, beguile her)

Adam: Nah, not yet . . . don't worry, I'm not gonna do
 anything to your stuff. No spray paint. I just . . .

Evelyn: I understand. Go ahead.

(*Action:* make her feel liked)

Adam: Thanks.

Evelyn: The door locks if you just close it. *BOO*

(*Action:* make her feel inconsequential)

Adam: Great.

*Evelyn smiles at him once more but says nothing. She heads for the
door but stops.*

Evelyn: . . . that one time. *YEA*

Adam: Huh?

Evelyn: In your bed, one night, when you leaned over and
 whispered in my ear . . . remember?

(*Action:* make her feel connected to me)

Adam: 'Course. I remember everything about us.

Evelyn: And I whispered back to you, I said . . .

Adam: I remember.

Evelyn: I meant that. I did.

Adam: Yeah?

Evelyn: Yes.

Adam: . . . oh.

She starts to say something else but catches herself. She goes out. Adam stands alone in the quiet room, looking out. BOO

The final question to ask at the end of the scene is, what do I do when I get what I want? Or, what do I do if I don't get what I want, when I don't achieve my objective? Answering that question will lead to your next objective. These objectives, linked together, represent a character's arc or journey through the play.

Improvising the Skeleton of Your Scene

Your first step after completing a character analysis and scoring your script is to put those choices into action by improvising the skeleton, the bare bones, of the scene. This is where "Who does what, with what, to whom, and why" becomes an area of exploration. Remember that an improvisation is not planned. Come to it with a complete understanding of the given circumstances presented in the text.

Complete the following before the first improvisation or the first rehearsal:

- Identify your objective and the obstacles, including your scene partner, that stand in your way.

- With your scene partner, create a *ground plan*. Determine where the playwright has set this scene. Open the space up

to your audience. Decide where you will place your entrances and exits and with your partner work through the logic and architecture of the space. Try to arrange furniture in such a way that you are open to the audience, but don't be afraid to give your ground plan depth and obstacles. The better the ground plan the more naturally the scene will stage itself. Walk through the scene with your partner several times before setting your ground plan. If you have a hard time justifying authentic movement, it may be that your ground plan is problematic. Just as a strong objective will help you play the scene, a good ground plan will enable fluid and dynamic staging. Part of the rehearsal process is experimenting with different ground plans. Don't be afraid to change your ground plan if you are feeling awkward or stuck on stage.

- With your scene partner, identify at least two primary beats in the scene.

At this point lines need not be memorized. This improvisation is a chance to build an authentic relationship with your scene partner, to discover your character's impulses for movement and stage business and to explore the conflicts and reversals inherent in the scene. Remember, stage business is any physical secondary activity, arbitrary (i.e., something created by the actor) or called for in the script, that an actor does on stage. It is a wonderful way of keeping the scene active. Writing a letter, putting on make-up, preparing dinner, setting a table, etc., are all examples of character-driven stage business.

It is also a chance to explore your objectives while experiencing unforeseen obstacles presented by your partner. In this way, you will discover new action choices and a more intense commitment to both

your character and your partner. These improvisations are also the ulti-
mate test of how playable your objectives are and if the stakes should
be raised in response to your partner's objective in the scene. After
every improvisation, take the opportunity to revise your objective and
raise your stakes. This exploratory improvisation can be repeated sev-
eral times for new discoveries.

Probing Your Scene

After the improvisation of the skeleton of your scene, you and your
partner will now memorize your lines to prepare for a probe (an inves-
tigation) of your scene. With the confidence of having tested your
objectives in the improvisation, you can now add dialogue.
Memorizing lines (dialogue) is often a monumental task for the begin-
ning actor. But if you understand what you are saying, the thoughts
you are landing (moment to moment), who your character is, and
how he or she speaks, this will be less of a chore than you anticipated.

Memorizing, like any other cognitive skill, requires repetition. The
more you memorize, the easier it becomes. With practice (rehearsing)
the lines become organically connected to your objective, actions, and
given circumstances.

A probe of your scene (i.e., your rehearsal process) is an explo-
ration not a performance, and is a chance to try out and test various
objectives and actions until a moment feels authentic. Recording
those choices that work in your script is essentially the process of scor-
ing your text.

The probe should be approached with freedom to move and relate
to your partner in an improvised way but with the added element of

memorized lines. During this part of the rehearsal process, introduce character-driven secondary activities. Let the given circumstances generate and inspire these activities. (Is it after work? Are you making dinner? Are you hanging out with friends? Are you rolling a joint or drinking a beer?)

Creating Imagined Environments

Environments are alive and changing and as important to the actor as the text. When considering environmental choices make sure you have first made a complete and thorough investigation of the text. Work from necessity. Ask yourself, "what do I need: what is necessary for *this* time and place, in the world of the play?" Choices are not random. This is not about dressing the set or stage. It is about working within a specific and detailed imagined environment.

Endow everything from the items in your pocket to the coffee cup you are drinking from with details that are specific to your character's world. In real life our belongings carry history and meaning, from the frying pan you received as a wedding gift to the purse you borrowed from your roommate and never returned, to the good luck charm you wear around your neck. They are never generalized. Everything your character interacts with carries meaning and can help to trigger an authentic emotional response. These props, when they become personal and specific to your character (as opposed to general and generic), bring texture and dimension to your scene. It may be subtle and nuanced, but it is palpable.

The more specific the environment is the more you are able to trick your body into behaving and responding authentically, as if you were

that character in that environment and situation. The richer the detail your imagination creates for your character's environment, the more believable your performance will be. Your body wants to know where it is in space; the more complete the environment, the more truthfully you can act. You must manipulate your body to believe in the given environment. Remember to consider the larger context as well—its social, religious, financial, political, and cultural aspects.

Endow your physical environment with specificity and meaning. When you look out through what we call the *fourth wall* (the imaginary wall that separates you from the audience and through which the audience views you on the stage) and out to the moon (in reality an exit sign in the theatre house), what do you see? What do you imagine? Is it a full and milky moon, a sliver of a moon behind clouds, or a sinister half-moon looming above? The more specific your visual image of the moon, the more specific that moment will be. If *you* see it, so will *we*, the audience. But be careful not to indicate (to point to) what you are imagining: don't show us the window, just see through it.

Defining Your Relationships

Now probe your relationships. All of your relationships to people, places, and things come from the past (what your relationships were) and live in the present moment (what they are now and what they move toward in the future, what they are becoming). All relationships usually have an element of fantasy (what you wish they were), an element of future fantasy (what you wish they could be), and an element of future nightmare (what you hope they won't become). And we tend to bring expectations to our relationships—expectations that are

usually not borne out in the course of the scene. What are your expectations?

Consider now how all of your senses—taste, smell, sight, hearing, and touch—relate to your environment and to your relationships, and how that environment and those relationships affect and inform your character's behavior and choices. The more specific your stage relationships and descriptions of your environment are in your mind (in your character's psyche), the more compelling your performance will be.

Staging Your Scene

Now you are prepared to add blocking (character-motivated movement) to your scene in preparation for a final performance. In most acting classes you are often working without a director to help you imagine the blocking. You and your partner must work together to create blocking for the scene, with an understanding of the logic of your imaginary space, and to specify the place, the time, the weather, and the world of the play.

Explorations of the scene from your improvisation and probe should reveal some organic, character-motivated blocking choices. It is general practice to move primarily on your own lines. It is most natural to move while speaking and moving on another actor's lines often steals focus. Like upstaging an actor who is speaking, it subverts landing the plot points (who does what, with what, to whom, and why?) of your narrative.

Notate your blocking in the same way you notate your score. Use a pencil because inevitably it will change as you learn more about the

scene and your character. Here is a shorthand way to write down your blocking in your script.

Upstage = U	Downstage = D
Stage Right = R	Stage Left = L
Cross or move on stage = X	Counter Cross = coX
Enter = ent	Exit = ex

The Importance of Rehearsal

In *Creating a Role* Stanislavski describes the operation of the actor's "inner model" of the role, which he also calls the score:

> With time and frequent repetition, in rehearsal and performance, this score becomes habitual. An actor becomes so accustomed to all his objectives and their sequence that he cannot conceive of approaching his role otherwise than along the line of the steps fixed in the score. Habit plays a great part in creativeness: it establishes in a firm way the accomplishments of creativeness. In the familiar words of Volkonski it makes what is difficult habitual, what is habitual easy, and what is easy beautiful. Habit creates second nature, which is a second reality. . . . The score automatically stirs the actor to physical action. (Stanislavski, 69)

In *Stanislavski Directs,* he says,

> But the law of theatrical art decrees: discover the correct conception in the scenic action, in your role, and in the beats of the play; and then *make the correct habitual and the habitual beautiful.* (Gorchakov, 77)

The rigor of repetition helps an actor incorporate their score, like their lines, into their muscle memory, keeping it fresh, alive, and focused. A productive rehearsal does not mean fixing a scene a certain way and then repeating it over and over again without change. It is an exploration; with each repetition you should discover something new. During the course of rehearsing your scene, adjust your focus, your attention, to specific elements of the score. How does a change in your action alter the interaction with your scene partner (receiver)? Does it become more dynamic or less? Let the immediate challenges inherent in your scene determine which focus you will choose to explore with your partner. Each rehearsal is an opportunity to further develop your scene; it builds on the work from your previous rehearsal.

Rehearsal possibilities may include the following:

- Run the scene with attention to the antecedent beat; add a sense of urgency or time, and see how this informs the interaction. What do you bring into the scene from the previous moment? Does this new focus help to enrich and enliven your scene?

- Work on the scene with a focus on ground plan. Try several options to create a more vivid environment, greater obstacles, and a more precise imaginary world. Bring in props that might hold meaning for your character. Which ground plan feels the most authentic and inspires the most fluid, organic staging?

- Explore possible secondary activities and run the scene with a secondary focus on those activities. How does this change your dynamic with the other characters in the scene? Does this give you a greater opportunity to reveal authentic

behavior? Does it give rise to obstacles that help to raise the stakes for your objective?

The exploration continues until something feels "right" and then, and only then, do you write it down as part of your score and thus "set it" for performance. Remember, in rehearsal, your performance will continually change based on what your scene partner is doing (to you). Just as a beat will shift when you change an action you are playing, so will your response shift when your scene partner changes the action he or she is playing. If your scene partner makes you feel something different, your reaction will now be different. As Sanford Meisner explores in his "pinch and ouch" exercises, your reaction is based solely on what your partner (the other character) does to you. If someone pinches you, you will most likely say "ouch!" If they kiss you, you will have a very different response. The more responsive you and your scene partner can be to one another, the more alive and exciting your performance will be.

As you rehearse the specific components in your scene, you will begin to internalize your score, making "the correct habitual and the habitual beautiful." Use the rehearsal journal that follows to aid you in this rewarding endeavor.

Rehearsal Journal

NAME _____

TITLE OF PLAY _____

SCENE NO. _____

ROLE _____

Time Begun:

Time Ended:

Date:

Place:

PROCESS/PROBLEMS

ADJUSTMENTS/SOLUTIONS

FOCUS OF THE REHEARSAL

- Psychological Score (objectives to tactics to action)

- Character Reversals

- Scene Shape/Arc

- Obstacles (physical and psychological)

- Ground Plan

- Staging/Blocking

- Secondary Activities

- Subtext/Inner Monologue (filling the unspoken beats)

- World of the Play/Environmental Details (time, place, weather)

A Note On Emotions

In both rehearsal and performance there is sometimes a tendency to push for or *to indicate* (reveal, show, direct attention to) an emotion or condition. Yet consider this: in real life we do not begin an interaction trying to be emotional or expecting to become emotional. Emotions, when they arise, are often a complete surprise to us and can be very embarrassing and present an obstacle to be overcome. For example, if we burst into tears in public, we may try to cajole ourselves out of crying; we may try to distance ourselves from the emotion with humor. We fight back our tears and attempt to calm ourselves down. Few people direct attention to emotional or physical ailments such as headaches, anxiety, upsets, boredom, and anger that arise in personal or public interactions; rather, they work to relieve, and often attempt to cover, the condition. Their *intention* is to make it go away.

In fact, it is more moving for an audience to see a character struggling to contain his or her emotions, fighting to keep back tears, and surprised by deep feeling welling up from within, than to see them overly emote. Watching an actor faking or pushing for emotion makes an audience uncomfortable and, if anything, pulls them out of the moment. This is not to say that you should suppress emotion that arises genuinely when performing. On the contrary, when emotion emerges out of a truthful interaction between you and your partner it

should be respected and expressed. If your score is complete and intrinsic to the character you have become, and if it is internalized along with your lines (text), you will find that the emotion inherent, or intended, in the scene will come to you when and where it should.

David Mamet, in his essay to actors entitled *True and False*, advises actors to remember, ". . . it is the audience who goes to the theatre to exercise its emotion—not the actor, the audience."

See Appendix A for appropriate scene suggestions.

Chapter 6

Exploration of Character: The Monologue

> Acting, therefore, can be defined as that process whereby the actor conceives the character and reveals him to the audience. Conception and revelation—the whole art can be summed up in those two words.
>
> Aristide D'Angelo

The monologue is an opportunity to create a thumbnail or snapshot of a complex and multi-dimensional character. The key to presenting an authentic glimpse of a character is to hook it as close to your own self (your own persona) as you possibly can. Finding (fully grasping) a character is easier than you think because no matter whom you are playing, they live inside of you. Your job, once you have carefully read your play, is to become an advocate for your character and to experience the story of the play through your character's point of view.

Don't judge your character; rather, discover the issues that your character might believe justifies his or her behavior. Create rationales and justifications from your character's point of view for your character's bad behavior. Bad behavior is at the core of good drama!

Most people never think of themselves as bad or evil. That is a judgment placed on them by others. Characters that exhibit bad behavior must have their own justifications and rationales for their behavior. If they are mean to a person, it is justified from their point of view because of the way that person treated them. If a man cheats on his wife, for example, he justifies it because his wife is not showing him enough love. Bad behavior makes for interesting characters, so don't act as a censor. Don't try to make your character "nice"; rather, relish the opportunity to exhibit behavior that will reveal a more intriguing and complex character.

Three-Dimensional Characters

Characters can be flat and stereotypic or round and multi-dimensional. For most contemporary performances, the latter is what we are looking for. We tend to picture ourselves in a positive light (as a caring and hard-working professor, a loving and devoted child, etc.), but this only represents one aspect of our being. There are many other "selves" lurking in the character we play on stage as well and, depending on the given circumstances of a play, different facets will emerge. This lends dimension and complexity to the performance.

Imagine you're on the phone with your mother, who is nagging you about why you haven't been home in over a month, and another call comes from your boss whom you are trying very hard to impress

with your professionalism. As you are talking to your boss, your boyfriend, with whom you are trying to make up after a fight, also calls. Although you do not have multiple personalities, various aspects of your persona emerge as you placate your mother, impress your boss, and appease your boyfriend.

Depending on who you are interacting with and what you want from that person, your personality may change. I am a caring and concerned professor until a student cheats in my class, and then I become tough, and although I don't think of myself as threatening, specific circumstances will trigger that element of my character. You may think of yourself as a pacifist, but if your child is physically threatened, you can kill another human being to protect the child.

As you read your script, you must not only understand the given circumstances but also explore how each interaction reveals another aspect (*color*) of your character's personality. To understand your character, however, you must first be willing to see yourself in a truthful light. You must be willing to look at your own behavior, both bad and good, as you honestly assess what choices are consistent with your character's behavior.

Selecting Your Monologue

Look for a monologue that reveals a character that interests you and that, on some level, you intuitively understand. Make sure the character you are playing is in your own age and personality range. Your job is to hook that character so close to your own persona that their words become your words, and their dreams become your dreams. Ideally, your choice would be a character you could be cast in today. Avoid

material that requires a dialect. Your monologue should be no more than two minutes in length.

Finding the right monologue is like going shopping for a very special outfit. You need to find a piece of clothing that will work with your body type, that you will be comfortable in, and that will accentuate your best parts and make a strong, distinct, and immediate impression. It is the same when choosing a monologue.

Your solo performance is an exploration of a fictitious character but needs to reveal some of your own personality and energy. Monologues are often used for auditions, as a way for a director to experience the acting style, personality, and mere humanity of the auditioning actor. The impression you leave must make the director interested in working with you. For that reason, avoid pieces with strong language, racist remarks, and inappropriate sexual innuendos; it will make those auditioning you feel uncomfortable and can often backfire on you.

Preparing Your Performance

Think of your monologue as a one-person show. This solo performance begins the moment you enter the room. Your job is to make a winning impression, and that begins with your hello and continues through the introduction, during which you present the piece you will be performing. Remember this is an opportunity for the people auditioning you to get to know you. The more relaxed, friendly, and responsive you are, the more engaged your audience will be.

As in the way you score a scene, begin by noting how your monologue actually ends and get as far away from that in the beginning as

you can. This will give you somewhere to go. Record your objective at the top of your monologue and indicate actions, the yeas and the boos, and parenthetical interior thought (subtext) along the margins. Try to find at least two beat changes (a change in tactic) to reveal more color. Finally, identify the It.

Remember that a character never intends to give a long speech when he or she begins to speak. A monologue is a long and active dialogue that comes out of a desire to win an objective. As you fight to win your objective and assess the opposing actor's response, the dialogue morphs and changes keeping it active and animated.

The first question to ask is, who am I talking to and what do I need from them? When real people speak, they have not memorized what they are about to say, and often they themselves are surprised and emotionally affected by what inadvertently comes out. So don't be so sure-footed with your lines. Find your words, and make your choices appear to come out of the moment as you discover your thoughts as if for the first time. Otherwise, the monologue will feel false and rehearsed.

The staging for a monologue is usually a chair and, at most, one hand prop. Like your duo scene, you must read the entire play so that you understand the journey up to this moment and what has happened before this moment that triggers your monologue.

Here are some tips for how to handle your monologue in an audition scenario:

- Dress in a comfortable manner that implies the status and background of your character.

- Self-introduction. Remember that your introduction is an opportunity to meet you, the actor behind the character, so

don't rush those opening moments with the persons who are listening to your audition. Make eye contact and really listen.

- Your auditioner wants you to succeed, so if for some reason you become lost, take a moment to compose yourself and, with their permission, start over.

- Don't direct your piece to the auditioners, but rather place the imaginary person you are speaking to out in the audience so that you are opened up toward the auditioners without looking directly at them.

- Avoid looking down. Your eyes are very expressive and the audience wants to see them in order to identify with you and the character.

- You may use a chair for part of your monologue, but it is always better to stage your piece on your feet with specific movement.

- Use a condensed area of the stage (6 x 6'); in general, start up stage, it will give you somewhere to go. Center stage and down stage center are strong choices for ending and for climatic moments in the monologue.

- Use a prop only if it is absolutely necessary and if it helps to reveal behavior that exposes more of the character's depth.

- Remember to thank the persons auditioning you at the end of your monologue. A genuine interaction is as memorable as your 8 × 10" photo (*headshot*).

Chapter 7

Acting for the Camera

Acting isn't lying, it's telling the deepest truth. The Sanford Meisner Technique is defined as the simple act of doing—of action borne on emotion, which takes place one honest moment at a time.

Sanford Meisner

Meisner and Film

Any discussion about film acting will always include Sanford Meisner. His "repetition exercises" and "pinch and ouch" techniques are all geared to help an actor react in an animated, authentic way each moment. (If someone pinches you, you react with an "ouch!") The point is to be alive and "real"—to react! This series of techniques will

help you to be believable, authentic, and animated on camera. In Meisner's own words:

> The greatest piece of acting or music or sculpture or what-have-you, always has its roots in the truth of human emotion . . . What I'm saying is that the truth of ourselves is the root of our acting . . . (Meisner, 45)
>
> I decided I wanted an exercise for actors where there is no intellectuality. I wanted to eliminate all that 'head' work, to take away all the mental manipulation and get to where the impulses come from . . . My approach is based on bringing the actor back to his emotional impulses and to acting that is firmly rooted in the instinctive. It is based on the fact that all good acting comes from the heart, as it were, and that there's no mentality to it. (Meisner, 36–37)

Learning to listen to and trust your instincts and impulses is key to honest acting. Remove the part of your head that edits and judges your intuitions. It will make you feel self-conscious, and the camera will capture that. Getting out of your head will free you to live in the moment, and the camera will love you!

The principles and basic values addressed in this handbook are at the core of all acting, including acting on camera. There is a misnomer that film acting is simply doing less. In fact, acting for the camera requires you to do more cognitive work, to abide in the interior world that animates your subtext, your inner thoughts.

Subtext and Film

Subtext is even more important in film than it is in theatre because the special quality of the camera when photographing dramatic material is that it can capture what is *unspoken*—what is happening behind the eyes. Framing the line with a *subvocalized* thought can help bring a dynamic or tension to the work that will make the actor more compelling to the audience of one (the camera). Effective cinema is not mere cinematography of actors talking. More likely, it is found in those fleeting moments when the character is either about to speak or when he or she is hearing an off-screen line and reacting to it. This is something that every experienced film editor can confirm. The editing of any dramatic exchange between two actors is much more likely to be timed to subtext than to the lines of dialogue.

What is your character really trying to say with his or her line? A paraphrase framed in parentheses preceding or following the actual line will help you to land those interior beats the camera is so interested in. What is the character's true intent behind the line? Remember, what a character says and what they really mean or think are often two very different things. People often say something to get something, not necessarily because it is truly and literally in earnest what they mean. Using the parentheses as a way of framing an interior moment is another way to score your script. The more visceral the parenthetical language (i.e., your interior thoughts) with which your subtext is worded, the more effective the non-spoken beat will be. Internalize those inner parenthetical thoughts as close to you as possible using language that your character would think and feel.

Because film is more interested in subtext than in text, shape your piece with specific moments or beats that are unspoken. Find a thought, an internal transition, that will permit the camera to get inside your character's thought process. Do not rush through the text; rather, make the text secondary to your internal thoughts and subtext.

Magic If

The camera will not respond to false or disingenuous "acting." It can tell when you are merely indicating meaning or emotion as opposed to experiencing the moment truthfully. So when acting for the camera, you must discipline yourself to be as authentic and honest as possible. This also takes you back to Stanislavski's magic If. *If* I were in these given circumstances, how would I feel and behave? What would I do to get what I want? The answer to these questions often lies in personal experiences that can evoke a similar inner state and similar behavior. Your job as a film actor is to use your own experiences (sometimes called sense memory) to find your own personal triggers that will evoke the necessary state of emotional and psychological being your character must experience. This will keep your work authentic and permit you to discover the behavior that is unique to your character and compelling on film.

State of Being

Because film is usually shot out of sequence, by identifying and being able to recall a particular state of being through your own personal emotional trigger, you will be able to pop into a scene, out of context,

but be at the right emotional and psychological pitch that the scene requires in order to fit into the linear narrative of the film. The other trick with film acting is for you to know the film well enough to understand where your scene and character fits into the story. It is your responsibility to know the backstory and the antecedent beat, what has just happened before this moment, and what informs this moment in terms of your character's objective and actions.

Reactions in Film

Because text has less importance or even relevance to the story in film, your reactions, listening skills, and behavior as it is revealed through your secondary activities carries a great deal of weight and will ultimately keep you from ending up on the cutting room floor! Not only are reactions essential in the context of the scene, they are key at the end of the scene. Just because there are no more lines does not mean you are to stop acting. Good directors will utilize the interior moments as a button for the scene or even in another part of the film. The lesson is to not stop acting until you hear the word "Cut."

Screen acting requires more reaction. Dialogue should be natural as you simply land your thoughts and ideas. However, as we've mentioned before, the less literal your dialogue is, the less you mean exactly what you say. And the greater the discrepancy between what you say and what you really mean, the more interesting you will be on film. *The camera likes secrets.* It is compelled by the notion that something is being covered; therefore, the more you harbor a secret, the more you mean something slightly different from what you are actually saying, the more compelling your screen work will be. Cover the truth or the emotion, and we will want to know more. We will

look for the meaning behind what you say. But if you honestly and literally mean everything that you say without a layer of subtext beneath your text, we lose interest in your character's journey and in you.

If you push for an emotional response or indicate an emotional response by "faking it," the camera will expose you. If, however, you cover your emotion, if you see it as an obstacle and fight to keep it contained, the work will feel active and truthful, and the camera—your audience—will believe you and, therefore, be compelled by your performance.

Staging and Stage Business for Film

In stage acting you are always being experienced from the perspective and point of view of a wide shot, as an audience peers through the proscenium arch. Film, on the other hand, is told for the most part in close shots. We create focus on stage with movement, but in a close shot a simple gesture or look—the lift of an eyebrow, the flash of your eyes—holds great power, weight, and meaning.

Understanding this will empower you to simplify your gestures. What on stage feels completely authentic, in a close shot looks absolutely burlesque. What was intended to be serious or frightening will seem humorous or silly. The problem then is a shift in tone. The more your gestures are geared toward an intimate and small acting space, the more the camera will respond favorably.

The rule of thumb is that the long shot in film is equivalent to acting in a large theatre with big gestures and full-body movements. A medium shot in film is like acting in an intimate theatre space or a black box theatre; act as you would in real life. The close up or extreme

close up in film, meanwhile, is akin to a magnified reality; just think your thoughts and they will read on screen!

Secondary activities are key to revealing character in both stage and screen. The way you interact with a piece of stage business gives us a great deal of information about what is happening to you in the moment and helps to create and define your character. If your character is agitated, they might read the newspaper or magazine differently than if they are just bored. The way a character prepares a sandwich for a boyfriend they know has been cheating on them will reveal a great deal about how that character is really feeling without that person ever having to say a word of dialogue. Props are your friend and will help you reveal much about your character.

The only reality in film exists inside the frame; therefore, be sure to *cheat your business* so it is captured within the frame. Even if it feels awkward or unnatural to you, as might standing closer than natural to a person in order to both fit into the frame, it will not read as odd in the on-screen reality. And the on-screen reality is what matters in acting for the camera.

When attempting to do business for film you must be careful to break it down to specific beats where the business is happening. Once you shoot your master, the rest of your *coverage* (i.e., your *close shot*, *two shot*, etc.) needs to be consistent and match that business from the *master coverage*. So if you pull out a cigarette on a particular line, light it on another line, and inhale at yet another point, your job is to *set* and remember where those movements come so that you can consistently match, take after take, your master coverage.

When movement or business is not consistent take after take, it poses a huge obstacle for the editor and, more than likely, your cover-

age will not be used. It is your responsibility as a film actor to _set_ and remember your movement and your secondary activities.

In previous chapters we have talked about the importance of opening up on stage so that the audience can identify with you and experience what you are experiencing. The more we capture your eyes the more we identify with your interior thoughts. Therefore, in the same way that we ask you to find appropriate motivation that will help you open out to your audience on stage, in film we ask you to *cheat* your thoughts toward the camera. Let it draw you, your face and your thoughts, like a magnet. It may seem easy to cheat your face to the camera, but the discipline and the technique of film acting requires motivating authentic thoughts so you are opened up to the camera lens. Think of the camera as your audience and let it in to share and identify with your experiences.

Unlike traditional theatre, which is designed for a proscenium and is wide, the lens captures depth. It is the opposite of the proscenium. We don't stand outside and watch; we (the camera) get inside in a three-dimensional dynamic way to capture the characters and the events from many angles. Therefore, as you block a shot, you want to move on stage for what Patrick Tucker calls "an imaginary red carpet that stretches out from the front of the camera" in a narrow but long axis—a direct line. Because the camera captures depth not width, stage/layer yourself in relation to others; think narrow but deep.

Selecting and Adapting Your Monologue for Screen

When researching monologues for a screen test, the most important element is to find a close match for your age and range. Like clothes

shopping, you are looking for an easy and perfect fit, for language you are comfortable using, and for syntax that you understand. It is also important to understand your type and to find a piece that supports that type, a role that you could conceivably be cast in one day. Don't perform a 40-year-old wife if you are a 20-year-old. Try to match your energy, your style, and your sense of humor as closely as you can. This is not an opportunity to stretch as an actor; it is an opportunity to land a part.

Dress the character for the part; dress as they would dress. If your character is a cowboy, wear boots, jeans, and a cowboy hat. Unlike a stage audition that should merely suggest who the character is, a screen test requires specificity and detail.

In summary, when acting for the camera:

- React before you speak and to the upcoming thought (this is best done on the intake of breath before a line).

- React while others are speaking on screen; we always watch the listening person.

- Because the camera cannot follow fast movements, lift the glass slowly into the frame; sit into or get up from your chair more slowly so the camera is sure to capture you.

- In film you do not need to vocally project to an entire audience in the theatre. Speak only as loud as you would to reach the person you are talking to.

- Remember, film is told in closer shots so let an acting impulse that would lead to a move on stage lead to a simple gesture, a look, or an eye flash on the screen.

- Don't just cheat your eye line open to the camera; motivate your interior thoughts in such a way that they play open and out to the lens.

- Never look directly into the camera lens. This is the same as when, on stage, you peer directly at the audience and speak to them in a direct address—what is known as "breaking *the fourth wall*." Look to the left or right of the lens when speaking to an off-camera character, not directly into the lens.

- Wear basic make-up! HD cameras and bad lighting will heighten every physical flaw and even magnify them in a close shot, so protect yourself by wearing a base to even out your skin tone, and powder to take down the shine.

Finally, remember that for camera acting to come across as truthful and believable, you need to be as honest and unselfconscious as you can. You need to be in the moment, listening and reacting to the other actors. But you also need to be aware technically of where the camera is, how your *business* is broken down, and what your staging should be. That technique is honed with practice. Any opportunity you have to act on camera you should take!

Chapter 8

Critiquing the Creative Work

> You will only fail to learn if you do not learn from failing. Falling flat on your face will uplift you!
>
> **Stella Adler**

As an acting student you will be expected to respond to performances on the stage and screen through written critiques. As a member of your acting class ensemble, your most important critiques will take place orally as you respond to each other's performances.

After years of critiquing performances, choreographer Liz Lerman developed an effective template for critiquing and developing creative work. Her philosophical approach is the foundation for many performance-based evaluation processes. The goal of this process is to make the student's unique, creative work stronger, more specific, and more impactful. This is not about building someone up or tearing them down. Therefore, when you are the one being critiqued, don't

begin the session expecting or wanting praise. Successful critiques lead to tangible advice that is worth its weight in gold. You and your scene partner take the suggestions (i.e., notes for improvement), which you then explore and try out in your next rehearsal. If those notes lead to changes (called *adjustments*) that fortify and deepen your performance, set them through rehearsal and repetition, and present the changes at your next performance.

The critique session is most useful in response to the "preview" performance of your scene or monologue. The preview is your first opportunity to present your work publically. The more prepared you are for that first performance, the more your work will inspire constructive critique. For the preview, your lines should be memorized and completely internalized, your ground plan should be established as specifically as possible, and you should already be introducing secondary activities and an effective blocking plan that flows naturally from your character's situation, objective, and actions.

The Oral Critique

It is best for performers to begin any discussion of their creative work by assessing how the performance felt from their own perspective. As Lerman writes in *The Critical Response Process*, "When the artist starts the dialogue, the opportunity for honesty increases." The more openly the performers can express their successes and frustrations and the more the class is cognizant of their process, the more constructive the critique will be. There are two preconditions when critiquing each other's work. One is to remember that we want this actor/these performers to achieve excellence. The second is to be able to form your

opinion in specific, non-judgmental, non-threatening ways—what Lerman refers to as a "neutral" response. Lerman recommends that the person offering a critique always begin with an affirmation that is honest and true, as in: "When you did such-and-such it was surprising, challenging, evocative, compelling, delightful, unique, touching, poignant, different for you, interesting, and many more."

Use the vocabulary you are encountering in this handbook in your critique. Some examples of constructive oral responses utilizing the language of acting follow:

- What was your objective in this scene? It seemed to lack drive; could the stakes be raised here?

- Although I liked the characters, there was lack of movement in your staging that undercut the dramatic impact of the scene.

- What secondary activity might your character be doing at the climatic moment that will create a greater obstacle for your character and, therefore, make the scene more dynamic?

- Where was the character coming from (antecedent beat) at the start of the scene? Your given circumstances seemed vague and unspecific.

- The characters did not seem to be listening to each other because there was a time lag between cue and response. Try to get the impulse to speak (respond to your cue) more quickly. By really listening to each other, instead of waiting for your next cue to be completed before responding, the dialogue will naturally overlap as real-life conversation does.

- You seemed to be making fun of your character—hook the character closer to yourself (be your character, don't stand outside of your character in judgment). Become an *advocate* for, and build a stronger identification with, your character by internalizing his or her rationales for their behavior.

Based on your remarks regarding what you have or have not observed in the performance, the performers can take that information and apply it in ways that will help them build a more specific and dynamic scene. Ask yourself, as you are formulating these neutral questions and remarks, what information have you garnered from the performance "intuitively" and "literally"? Consider, too, where you are confused and why that might be. How much did you understand of the world of this play based on this scene? Asking yourself these questions will help you formulate honest and constructive questions that will lead your fellow actors to make positive adjustments to their scene.

Part of what makes an acting class successful is the opportunity to critique work other than your own. Sometimes it is harder to understand a concept when you are in the "hot seat" being critiqued for your work. Being able to experience these techniques and concepts through your peer's work is as valuable as doing it yourself. Therefore, when critiquing your peer's work and listening to the class and your acting teacher critique and offer adjustments, ask yourself how all of these responses might apply to your own performance. Always keep your notebook out so that you can write down the points that speak to your own tendencies as an actor and your own challenges in your process of rehearsing and performing.

Written Critiques

We are hoping through this handbook to help you develop a greater understanding of character and point of view. Therefore, when critiquing a production in the context of this acting class, we encourage you to adopt the perspective and through line of one particular actor/character, whether it be the actor that helped connect you to the story or who, for you, subverted your connection to that story. We ask you to discuss their performance in writing, once again utilizing the language of acting.

The following paragraphs describe a useful format for a written critique of another actor.

Introduction: The introduction should capture the reader's attention. It should provide a hook that engages and compels your audience to read on (it might be an excerpt from a play, a quote from a review, or a biographical anecdote about the playwright). A thesis statement for this type of performance review should focus on one actor's interpretation of a key role. It can be the protagonist or the antagonist, as long as their character's *arc* sustains itself throughout the play. Here is an example of a critique of SITI Company's production of *A Midsummer Night's Dream:*

> However entertaining a script may be, it is really up to the actors to capture the audience. Though all the performers were equally compelling, it was Tom Nelis in his roles as Theseus, Oberon, Quince who really captivated me.

Body: The body of the critique should contain <u>two to three para-</u> <u>graphs describing specific examples of the actor's performance</u> that support your thesis. You might note something about the actor's training and past experience (as found in the program, for example) as it informs the performance you are critiquing. For example:

> As Oberon, King of the Fairies, Nelis utilized his background in Anne Bogart's Viewpoints and Suzuki training which was palpable in this highly physicalized portrayal. Always teetering on his toes, as if on point, his demeanor felt light and otherworldly. In the scene where jealous Oberon drops the potion into Titania's eye as she sleeps, watching his lean body navigate down the raked, mirrored stage evoked the image of a graceful hawk pouncing on his prey.

Conclusion: Restate your thesis at the top of the paragraph; then <u>expand your conclusion into a more general response</u> to the overall theatrical experience of this production. For example:

> While the entire ensemble was obviously skilled and connected to the world of this play as conceptualized by director Anne Bogart, it is Tom Nelis who was most compelling in his various roles. Watching this single actor morph from the fairy king, to the tentative Peter Quince and finally to the pragmatic Theseus, was awe-inspiring. Not only was each character vibrant, distinct, and compelling, but also the contrast between each helped to define the world of the play as I have never before experienced it. This is a production not to be missed and a performance of a lifetime.

Through critiquing performance and being critiqued yourself, you will begin to feel comfortable with this performance lexicon and with the notion of adjustments. Critique does not mean criticism. It should be embraced and received as an opportunity to continue honing your skills as an actor.

"Begin at the beginning," the King said, very gravely, *"and go on till you* come to the *end: then stop."*

Lewis Carroll, *Alice in Wonderland*

We hope this handbook has helped you to trust your instincts and intuitions, to jump before you edit your impulses, and to find freedom and truth in artful expression. Hopefully this beginning acting experience has also helped to demystify the art and craft of performance. Whether you go on to become a more informed audience member who appreciates the nuance and beauty of an authentic performance or a performer yourself, our hope is that you bring with you the values that live at the core of truthful human behavior and that illuminate the human condition.

Acting is an exploration. Like an archaeological dig, it will lead to the unexpected, and ultimately reveal more about yourself and the human experience than you could ever have imagined when you first began. Keep this handbook as a reference and reminder of basic acting values and performance techniques. May you find joy in expression and a lifelong passion for storytelling? Watch as many films as you can and attend as much theater in your community as you can find, it will make you a richer human being, and, if you choose the path of acting, it will lead you to deeper and more effective performances.

By beginning at the beginning, and trusting in the craft of acting, in the steps you must take to find your character and define the beats of each scene and the through line of your journey, you will, undoubtedly, come to the end. Without fear or anxiety, just by doing the work, you will find the magic and satisfaction that comes from illuminating human experiences.

Simply, act.

Appendix A

Suggested Plays for Student Scenes and Monologues

These plays offer a range of subject matter and roles suitable for a diverse population of college-age students. Please note, however, that some scenes contain strong language and mature themes. Teachers: select scenes that best match the abilities and makeup of the students in the class. Students: choose scenes that speak to you!

Contemporary Plays

Alan Arkin and Elaine May

 Power Plays

David Auburn

 Proof

Annie Baker

 The Aliens

 Body Awareness

Michael Christopher

 The Shadow Box

Steven Deitz

 The Nina Variations

Rebecca Gilman

 Blue Surge

 Spinning into Butter

 The Sweetest Swing in Baseball

Tom Griffin

 The Boys Next Door

Stephen Adly Guirgis

 Jesus Hopped the 'A' Train

 Our Lady of 121st Street

Rajiv Joseph

 All This Intimacy

 Huck and Holden

 North Pool

Stephen Karam

 Speech & Debate

Tony Kushner

> *Angels in America*
>
>> Part One: *Millennium Approaches*
>>
>> Part Two: *Perestroika*

Neil LaBute

> *The Distance from Here*
>
> *reasons to be pretty*
>
> *The Shape of Things*
>
> *Some Girl(s)*

Tracy Letts

> *August: Osage County*
>
> *Bug*

Kenneth Lonergan

> *This Is Our Youth*

Lisa Loomer

> *Living Out*

Craig Lucas

> *Blue Window*
>
> *Prelude to a Kiss*
>
> *Reckless*

David Mamet

 Glengarry Glen Ross

 The Old Neighborhood

 Speed-the-Plow

Jane Martin

 Criminal Hearts

Steve Metcalfe

 Strange Snow

Miguel Piñero

 Short Eyes

Theresa Rebeck

 Bad Dates

 Loose Knit

 Mauritius

 The Scene

 Spike Heels

Sarah Ruhl

 The Clean House

John Patrick Shanley

 Danny and the Deep Blue Sea

 Doubt: A Parable

The Dreamer Examines His Pillow

Italian American Reconciliation

Savage in Limbo

Sam Shepard

True West

Nicky Silver

Fat Men in Skirts

Diana Son

Stop Kiss

Paula Vogel

The Long Christmas Ride Home

Michael Wall

Amongst Barbarians

Annie Weisman

Be Aggressive

August Wilson

Fences

Joe Turner's Come and Gone

The Piano Lesson

Craig Wright

Orange Flower Water

The Pavilion

Modern Classics

Edward Albee

The Death of Bessie Smith

Michael Gazzo

A Hatful of Rain

Jean Giraudoux

The Madwoman of Chaillot

Lorraine Hansberry

A Raisin in the Sun

Henrik Ibsen

A Doll's House

William Inge

Picnic

Arthur Miller

All My Sons

The Crucible

Death of a Salesman

A View from the Bridge

N. Richard Nash

The Rainmaker

Clifford Odets

 Golden Boy

William Saroyan

 The Time of Your Life

Thornton Wilder

 Our Town

Tennessee Williams

 Cat on a Hot Tin Roof

 The Glass Menagerie

 Orpheus Descending

 A Streetcar Named Desire

 Summer and Smoke

 27 Wagons Full of Cotton

Appendix B

Suggested Reading

There are hundreds of books on the subject of acting, but these selections have provided inspiration for us in the classroom over the years and are the major sources for this handbook.

Antoine Artaud

> *The Theatre and Its Double*

David Ball

> *Backwards & Forwards: A Technical Manual for Reading Plays*

William Ball

> *A Sense of Direction*

Tony Barr

> *Acting for the Camera*

Augusta Boal

> *Games for Actors and Non-Actors*

> *Theatre of the Oppressed*

Anne Bogart

and then, you act: Making Art in an Unpredictable World

Anne Bogart and Tina Landau

The Viewpoints Book

Peter Brook

The Empty Space

Michael Caine

Acting in Film

Marina Caldarone and Maggie Lloyd-Williams

ACTIONS: The Actors' Thesaurus

Michael Chekhov

To the Actor

Nikolai Gorchakov

Stanislavski Directs

Jerzy Grotowski

Towards a Poor Theatre

Uta Hagen

Respect for Acting

A Challenge for the Actor

Keith Johnstone

Impro: Improvisation and the Theatre

Jon Jory

 TIPS: Ideas for Actors

Robert Lewis

 METHOD—Or Madness?

Liz Lerman

 Critical Response Process

Kristen Linklater

 Freeing the Natural Voice

David Mamet

 True and False: Heresy and Common Sense for the Actor

Sanford Meisner and Dennis Longwell

 Sanford Meisner on Acting

Vsevolod Meyerhold

 Meyerhold on Theatre

Michael Shurtleff

 Audition

Viola Spolin

 Improvisation for the Theater

 Theater Games for the Classroom: A Teacher's Handbook

Constantin Stanislavski

 An Actor Prepares

 Building a Character

 Creating a Role

Lee Strasberg

A Dream of Passion: The Development of The Method

Tadashi Suzuki (trans. J. Thomas Rimer)

The Way of Acting

Glossary

actions—the things you do or say to another character in order to achieve your objective; the specific behaviors you engage in to put your tactic(s) into play; for example, if you decide to use seduction (tactic) in your attempt to get X to marry you (objective), you might wear a revealing outfit and attempt to make X feel attractive, important, and adored (actions).

adjustments—the changes you, as an actor, make; usually based on notes from the director.

antecedent action/antecedent beat—the inciting incident that has propelled us into the scene; what happens just before the play or scene begins.

arc—a character's journey or transformation in the course of the play; the overall shape of a character's journey in an individual scene or throughout an entire play.

beat—a one-count rest; a technical term for the timing of a pause (one beat is one count or second; three beats equal a "three-count" rest, etc.); the moment-to-moment reversals or shifts (of direction and/or tactic) that occur between characters in a scene.

blocking/staging—character-motivated movement in a scene.

boo—a loss; a negative moment for you (i.e., for your character).

cheat your business/to cheat—to open out toward the audience or the camera (your audience of one).

coverage—in film, the specific shots that the director must include in order to put together a scene; for example, two people eating lunch might entail one shot of the two together (a "two-shot"), matching close shots of each character, an extreme close shot of the protagonist, and several close "cutaways" to the clock on the wall, the food eaten, etc.

to endow—to give specific objects or the environment meanings and properties they don't ordinarily have; for example, a cardboard sword can be endowed with the properties of Excalibur, the legendary sword of King Arthur, if you so endow it (if you see and believe the sword in your hand is Excalibur, so will the audience); a cheap dime-store ring can be transformed into a priceless treasure if you so endow it.

event/the "It"—the defining moment in a scene where change occurs; it is at this moment that a condition that existed at the beginning of the scene no longer exists, or a condition that was absent at the beginning now exists; the ultimate event in the arc of a play is called the "climax."

fill/to fill—to invest or imbue a moment with subtext (see *subtext*).

the fourth wall—the imaginary wall that separates you from the audience and through which the audience views you on the stage.

given circumstances—for any scene, the specific facts and conditions of the physical environment—time, place, weather, situation, etc.—as well as the inner thoughts, justifications, and emotional and physical makeup of the character(s).

ground plan—the physical arrangement of furniture in a space and the perceived physical structure or architecture of that space (entrances, exits, windows, hills, etc.); a successful ground plan elicits fluid and dynamic staging.

the magic If—imagining how you would behave if you were in your character's shoes; the "magic If" requires you to respond as you would if this were your own situation or story, to "hook" your character as closely as you can to your own being; drawn from Stanislavski's basic theory of acting.

master coverage—in film, a long or wide shot that covers everyone in the scene at once; this is sometimes called an "establishing" shot and is usually the first shot taken when shooting a scene; it is the foundation of what we call *camera coverage.*

objective—an immediate goal, need, or intention of a character in a scene.

obstacle—a person, object, or emotional or physical state of being that gets in the way of your achieving your objective; obstacles intensify your struggle or quest to gain your objective and so provide wonderful opportunities to create drama or comedy in a scene.

plot points—who does what, with what, to whom, and why.

probe—to investigate or explore a particular element of your scene as part of the rehearsal process.

receiver(s)—the other character(s) that you interact with in your scene.

reversal—the yeas and boos that define whether a beat is good for your character or not; a change in direction or tactic that determines whether your character is winning his or her objective or not.

scoring a script—writing the following in the margins of the script: the expectations of your character; what your character hopes will happen in this scene; your character's objective, tactic(s), and related action(s); reversals (yeas and boos); event(s) (the "It"); a subsequent objective (what does your character do after reaching, or failing to reach, the objective?); and other interpretive notes.

secondary activity/stage business—what you are doing in the context of a scene—for example, washing dishes, knitting a sweater, smoking a cigarette; stage business animates your scene and helps reveal character through behavior.

stakes—what is at risk if you do not attain your objective; the higher the stakes the more dynamic (dramatic or comedic) the playing of your scene will be.

subtext—the interior meaning that is motivating and justifying what you actually say (i.e., the lines of text) and how you actually behave; your character's stream of consciousness as you play the scene.

super objective—the overriding motivating desire or need that determines your character's behaviors and actions throughout the play; not to be confused with your character's specific objectives in any given scene; the super objective usually colors and informs the other objective(s) in a scene.

tactic(s)—the strategies you employ to attain your objective; such strategies determine the character's specific actions.

through line/spine—a series of objectives that forms a chain of events that leads, scene by scene, to the end of the play.

viewpoints—an acting technique derived from the terminology of dance choreography and developed by Anne Bogart and the SITI Company; a holistic dance-inspired approach to physical, vocal, and mental training for actors.

yea—a win; a positive moment for you (i.e., for your character)